Crooked Beak of Heaven

Crooked Beak of Heaven
*Masks and Other Ceremonial Art
of the Northwest Coast*

By Bill Holm

Published for the Thomas Burke Memorial
Washington State Museum and the Henry Art Gallery
by the University of Washington Press,
Seattle and London

Crooked Beak of Heaven is the catalogue of
the Sidney Gerber Memorial Collection of
Northwest Coast Indian Art in the Thomas Burke
Memorial Washington State Museum.

Library of Congress Cataloging in Publication Data

Washington (State). University. Museum.
 Crooked beak of heaven.

 (Index of art in the Pacific Northwest, no. 3)
 "Catalogue of the Sidney Gerber Memorial
Collection of Northwest Coast Indian Art in the
Thomas Burke Memorial Washington State Museum."
 Bibliography: p.
 1. Indians of North America — Northwest coast of
North America — Art — Catalogs. 2. Gerber, Sidney
— Art collections. 3. Art — Seattle — Catalogs.
I. Holm, Bill, 1925- II. Henry Art Gallery.
III. Title. IV. Series.
E78.N78W3 709'.01'1 77-39631

ISBN 0-295-95172-9
ISBN 0-295-95191-5 (pbk.)

Photo Credits

All photographs are by Douglas Wadden
with the following exceptions:
Page 8: Dr. C. F. Newcombe
Page 9 (bottom): Wilson Duff
Page 11 (top): Robert Jensen
Pages 28, 43, 57, 76, 83: William Eng
Page 93 (bottom): Roger DuMars

Colophon

The text of this book was set in various sizes of
Helvetica Light, Medium, and Bold. The book
was printed on Champion Wedgewood Offset,
dull coated. The cover of the paperbound edition
is Kromekote Cover. Composition is by
Typoservice, Indianapolis; offset lithography by
the University of Washington Department of
Printing. The clothbound edition was bound by
Lincoln and Allen, Portland, Oregon.

Designed by Douglas Wadden.

Foreword

The third volume of the Index of Art in the Pacific Northwest, a cooperative venture of the Henry Art Gallery and the Thomas Burke Memorial Washington State Museum of the University of Washington, documents the Sidney Gerber Memorial Collection of Northwest Coast Indian Art, now permanently housed in the Burke Museum. It also serves to mark an exhibition of Northwest Coast Indian masterworks, complementing the Gerber Collection, held at the Henry Gallery in March 1972.

This book is a most appropriate addition to the Index because it is concerned with the art of the first artists of the Pacific Northwest, the native American Indians who were subjugated by invading white men from Europe and Eastern North America. It also seems appropriate, in this context, that Ann and Sidney Gerber, who collected the Indian art encompassed in this catalogue, were early champions of civil rights. Together the Gerbers worked long and hard for equal opportunities and especially for equal housing rights for all peoples regardless of color, creed, or ethnic identity.

The Gerbers appreciated and collected a broad range of art which included Northwest Coast Indian art as well as contemporary Western art. They began to acquire Indian art in the 1940s. Most of their collection was purchased from Indians in remote villages at the north end of Vancouver Island which they reached by sailboat or private plane. The Gerbers continued to collect Northwest Coast Indian art until Sidney Gerber's death in 1965. By that time the Gerber Collection of Northwest Coast Indian art was one of the most important in the United States.

In 1969 Ann Gerber donated her collection of Northwest Coast Indian art to the Burke Museum. This magnificent collection, a memorial to her late husband, when added to the existing holdings of the Burke Museum, made the museum's collection truly outstanding in western North America. In 1970 the Gerber Collection was placed on exhibit in the museum's hall of Northwest Coast ethnology. At that time the museum planned to produce a suitable catalogue as soon as feasible.

In the meantime the Henry Art Gallery had inaugurated the new series, Index of Art in the Pacific Northwest. Almost immediately it was recognized that this series was the ideal vehicle of publication for the catalogue of the Gerber Collection and thus began the cooperative venture of the Burke Museum and the Henry Gallery. This venture has been aided by a substantial grant from PONCHO.

Bill Holm, lecturer in the School of Art at the University of Washington, adjunct lecturer in anthropology, and curator of Northwest Coast Indian Art at the Burke Museum, maintains warm, personal ties with the Kwakiutl people. His book, *Northwest Coast Indian Art: An Analysis of Form*, is one of the best books ever written on this subject, and he has been selected by the Smithsonian Institution to write a section on Northwest Coast Art for their forthcoming *Handbook of North American Indians*.

We wish to thank Ann Gerber for the thoughtful gift of the Sidney Gerber Memorial Collection to the Burke Museum, where it can be studied and appreciated by generations of students. We also wish to thank PONCHO for the grant to the Henry Art Gallery which supported this publication.

George I. Quimby
Director, Thomas Burke Memorial
Washington State Museum

Spencer Moseley
Director, School of Art
Acting Director, Henry Art Gallery

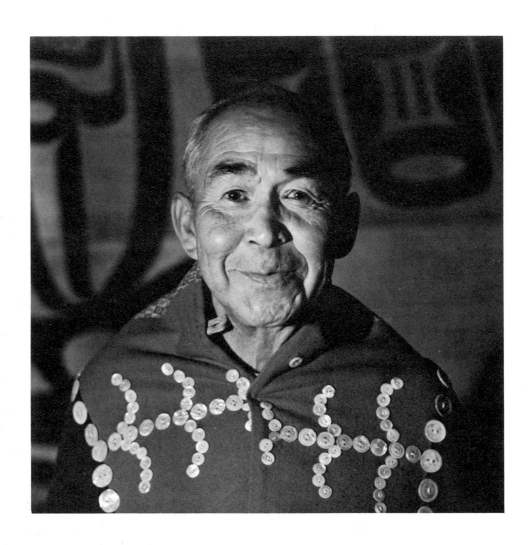

Joe Seaweed, 1971

"I will talk about the middle between our world and the upper side of what is seen by us, the blue sky where the sun and moon and the stars stay, that is what I mean, the names of the various birds of the Rivers Inlet tribe, the Crooked-Beak-of-Heaven and the Hōxᵘhōkᵘ-of-Heaven and the Raven-of-Heaven and the Screecher-of-Heaven and the Oogwa'xtâᶜyē, and many others whose names I do not know, the various birds above the clouds."

(From *The Religion of the Kwakiutl Indians* by Franz Boas)

Introduction

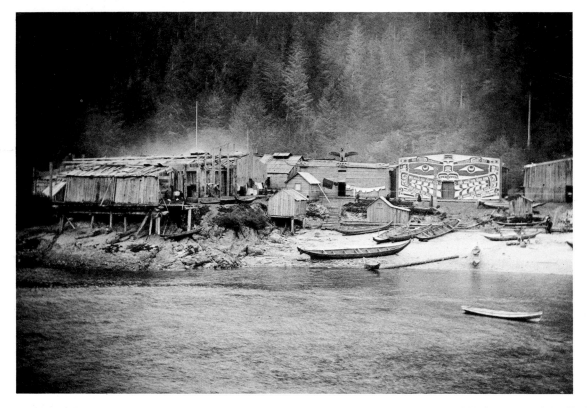

Guilford Island around 1900 (courtesy of the British Columbia Provincial Museum)

In October 1968, Mrs. Ann Gerber presented to the Thomas Burke Memorial Washington State Museum the collection of Northwest Coast Indian material, consisting of 124 pieces, which she and her husband Sidney had gathered over the previous twenty years. Ann Gerber designated the gift a memorial to her husband who, to the time of his death, had built a remarkable record of philanthropy to the city of Seattle and its citizens. It is especially appropriate that this collection of the fine art of a `culture other than that prevailing in our time should be given in memory of Sidney Gerber, who gave direct and positive leadership to the struggle for universal equal rights.

The Gerber collection is remarkable in a number of ways. It is well known in the Pacific Northwest, where it has often been generously loaned and shown, either entirely or in part, in public exhibitions, including the Vancouver Art Gallery's 1967 Centennial Exhibition of Northwest Coast Indian masterworks, "Arts of the Raven." It was at the time of its transfer to the Burke Museum perhaps the largest and most significant private collection of Northwest Coast Indian art in the Pacific Northwest and ranked with the finest in the world. But in order fully to understand its unique contribution to the Burke Museum it is necessary to review briefly the history of that institution's collections.

The first important body of Northwest Coast material in the museum, a collection of some 230, was gathered primarily by James G. Swan and the Reverend Myron Eells for the World Columbian Exposition in Chicago and came to the Burke Museum from the Washington World's Fair Commission in 1893. Over the years the Northwest Coast Indian collections swelled to nearly seven thousand pieces, but of these a fairly large proportion cannot be categorized as art in the usual sense. The largest single collection represented, and one rich in pieces of artistic value, is that assembled by Lieutenant George T. Emmons and acquired from him in 1909 and 1913. The Emmons collection includes many fine examples of northern Northwest Coast painting and carving, especially from the Tlingit, and is meticulously documented. Another large and important collection of some 350 pieces, primarily baskets, came to the museum in the mid-1940s from Mrs. Thomas Burke. In 1953 the Burke Museum, together with the Denver Art Museum, acquired the collection of the late Walter Waters of Wrangell, Alaska. From this material the museum gained over three hundred pieces including major masterpieces of Northwest Coast Indian art. Smaller collections and individual pieces from various sources added to the total.

With a few exceptions, the collection of Indian art objects from north of the Coast Salish area consisted of Tlingit pieces. The northern British Columbia coast area was barely represented save by a few Haida and Tsimshian pieces and an occasional Kwakiutl mask. In the Waters Collection

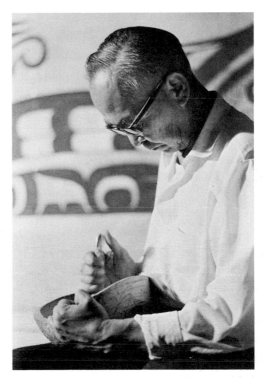

Joe Seaweed Carving a Mask

Chief Willie Seaweed, Blunden Harbour, 1955 (courtesy of the British Columbia Provincial Museum)

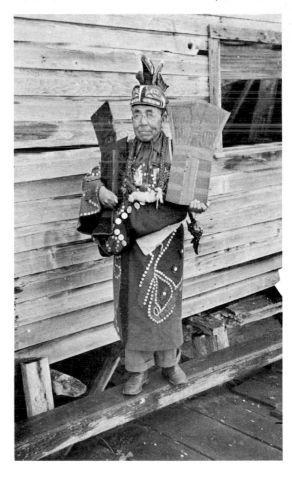

9

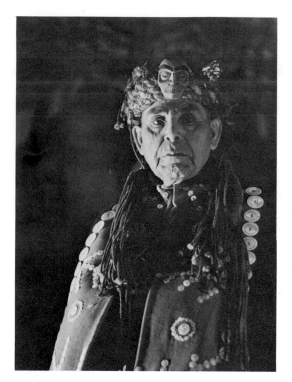

Chief Henry Bell, 1971

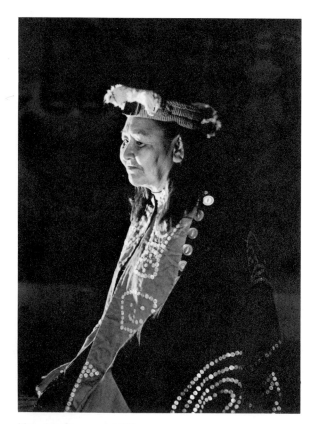

Mrs. Joe Seaweed, 1971

were a number of fine Kwakiutl masks, and this group was augmented by gifts of several others of superb quality from John Hauberg, owner of a major Seattle collection.

With the Gerber gift, the situation changed radically. Very rich in Kwakiutl masks and ceremonial paraphernalia, it filled the void and rendered the Burke Museum collection much more comprehensive. Similarly, the exquisite examples of very early Haida argillite carving among the Gerber pieces perfectly complemented the relatively small group of fine late nineteenth-century pieces already in the museum.

Considering its size and quality, the late collection date of the Gerber material is surprising. The majority of the Kwakiutl pieces were purchased directly from the Indian owners in the 1950s. This would hardly have been possible almost anywhere else on the coast. The Kwakiutl have kept much of their ceremonial culture essentially intact; old masks are still retained and used, and new masks (and other forms of ritual art work) are continually being produced. Objects generations old share places in the collection with contemporary pieces.

Approximately one half of the Gerber Collection is of known or attributed Kwakiutl origin and consists in large part of objects for ritual use. Of these pieces half are masks, representing nearly all types made and used by the Kwakiutl, who perhaps of all the Northwest Coast tribes carried the masking complex to its greatest elaboration.

The great majority of Kwakiutl masks are worn in representations, in stylized dance form, of incidents from hereditary family myths. In some cases the dance dramatizes the mythical adventure of the ancestor, while in others it recreates a dance given to the ancestor by a mythical being with whom he came in contact. In either case the dance and the accompanying songs, masks, and regalia are regarded as valuable family privileges to be passed on in the family from generation to generation. Certain of these privileges, especially those that seem to be part of ancient Kwakiutl tradition, are inherited according to the rule of primogeniture in the male line, while others, including those that have been acquired in historic and protohistoric times by the Kwakiutl, are typically treated as important parts of dowries in noble marriages.

Kwakiutl dances and, by extension, the masks worn in them can be categorized as belonging to one of several different dance complexes or ceremonials. The most important of these, richly represented by masks in the Gerber Collection, is the Tséyka. The dances of this ritual complex, usually referred to in English as the "Winter Ceremonial," are in a sense considered sacred, but the main motivation for them in historic times has been a social one, the public display of valued family privileges. Kwakiutl winter dances, in contrast to the religious dances of many other American Indian groups, are staged dramatic

performances. The spirit dances of the Salish of Georgia Strait and northern Puget Sound, for example, are deeply personal responses to intense supernatural experiences of the dancers themselves. In many ways, however, the Kwakiutl dances do resemble the Salish power dances, and the stories upon which they are based, describing the ancestor's experience, are not unlike the accounts of the spirit encounters of the Salish.

The most important of the Kwakiutl Tséyka dances is the *hámatsa,* which is said to have been acquired in the early years of the historic period from related tribes to the north by marriage and war. *Hámatsa* can be roughly translated as "cannibal," and the dancer impersonates and is considered to be motivated by Bákhbakwalanoóksiwey, a powerful man-eating spirit. Whatever the underlying meaning of the drama of the novice's kidnaping and transformation by the cannibal spirit, his return to his village as a wild man-eater, his capture and taming by means of dances and songs, and his ritual purification, present-day Kwakiutl regard the performance as a prestigious display of a valued prerogative. The initiation of a new *hámatsa* is very expensive when carried out properly, involving as it does the sponsorship of a number of dance festivals during the winter (sometimes for four consecutive winters), the preparation of the ritual paraphernalia, and the payment of large sums to the witnesses by way of validating the displayed privilege. Without this payment the whole affair would be meaningless, as the unvalidated claim is valueless.

Masks representing the associates of the cannibal spirit Bákhbakwalanoóksiwey are worn by dancers during part of the ritual of taming the new *hámatsa.* These depictions of monster birds with great snapping beaks are among the most spectacular of Northwest Coast masks. The masks as well as the dancers' bodies are hung with shredded cedar bark, some of it dyed red. This red bark is symbolic of the Tséyka ceremonial, and its presence on a ritual piece is a good indication that the object was made for use in that ceremony.

There are other great ceremonial festivals of the Kwakiutl involving the use of masks and ritual objects. Chief among these is the Tlásulá, not unlike the Tséyka in its sequence of the disappearance of the novice, his return, and his taming. The motivating spirits, the form of the dances and masks, and the characteristic symbolic materials used are, however, all very different from the corresponding features of the Tséyka. Beautifully carved headdresses inlaid with abalone shell and adorned with long ermine trails are featured in part of this dance series, giving rise to the contemporary Kwakiutl English term "Weasel Dance" for the Tlásulá. In contrast the Tséyka is commonly referred to as the "Cedar Bark Dance." Large and complex masks, frequently fitted with movable parts, or constructed as a mask within a mask, make the dramatization of the actions and

transformations of supernatural beings graphic and awesome. The complexity and multitude of stories upon which the dance-dramas of the Kwakiutl are based afford the artists almost limitless opportunity for expression in masks and other ceremonial paraphernalia.

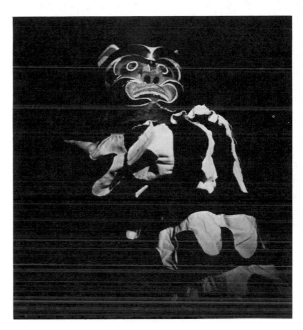

Bukwús Dance

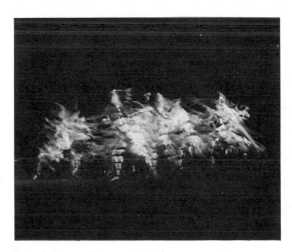

Bukwús Dance (time exposure)

Note on Pronunciation

It is impossible to give an accurate indication of the sound of the Indian words included in the following pages using the ordinary English alphabet. An attempt has been made, however, to spell them in such a way that the native pronunciation can be approximated. Some sounds important to the languages which are extremely difficult for speakers of English have been rendered with the nearest equivalent letter. These include the velars and explosives. Others are indicated by combinations of letters, as shown in the following key. An English-speaking person pronouncing the sounds carefully according to the key will be able to produce words at least recognizable to a native speaker of the Kwakiutl language.

a	father	ts	itself
ai	Taiwan	dz	adzing
e	get	kh	Bach
ey	they	ky*	thank you
i	machine	gy*	egg yolk
o	note	dl*	hardly
oo	food	tl*	rightly
u	up	hl*†	softer than tl
hy	hue		

w following final consonant is silent but indicates lip position.
All other consonants as in English.
* No vowel value, even when terminal.
† Press the tongue against the roof of the mouth and let breath escape at the sides.

The Northern Northwest Coast

Alaska

Tlingit

Canada

Tsimshian

Haida

Queen
Charlotte
Islands

Bella Coola

Bella
Bella

Kwakiutl

Pacific Ocean

Coast Salish

Vancouver Island

Nootka

N

U.S.A.

Kwakiutl

Tséyka Masks

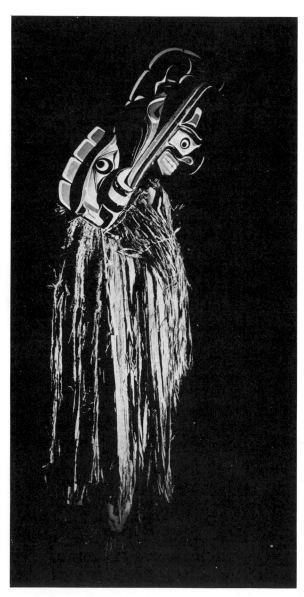

Crooked Beak Mask Dance (the dancer is concealed by the hanging cedar bark)

1. **Crooked Beak Mask.** Wood, cedar bark.
 L. 34 in. 25.0/2

Perhaps the most spectacular of the articulated masks of the Kwakiutl are those representing Galókwudzuwis, "Crooked Beak of Heaven." One of the mythical birds of the upper regions, Galókwudzuwis was included among the man-eating associates of Bákhbakwalanoóksiwey. In the mythology of the *hámatsa* dance, those associates are spoken of as persons who own masks that transform them when they are donned, although in some accounts they appear as actual birds and animals. In the same way the dancers are recognized as mask-wearing men who take on the powers and characteristics of the being represented by the mask, and the mask itself is referred to in this way in the song that accompanies the dance. This *galókwumhl* (crooked beak mask) epitomizes the flamboyant elaboration characteristic of Kwakiutl masks of the twentieth century, particularly those made by carvers from the village of Blunden Harbour. Earlier masks of this type are much more restrained in form and surface decoration. The wide flat mouth and strongly arched beaklike nose are the features that distinguish the Crooked Beak from the other *húmsumhl* (cannibal masks), all of which are carved of red cedar and decorated with shredded inner bark of the cedar partially dyed red. The jaws are hinged and rigged with cords, enabling them to be snapped sharply at certain points in the dance. Cannibal masks are worn on the forehead at an upward angle, with the mask covering the sides and back of the dancer's head and his face concealed by the hanging bark fringe. A strong harness tied around the chest under the arms helps to support the mask, which is manipulated by the dancer's hands, grasping the edge of the mask under the bark fringe.

The mask was made before 1940 by Charlie George, Sr., of Blunden Harbour.

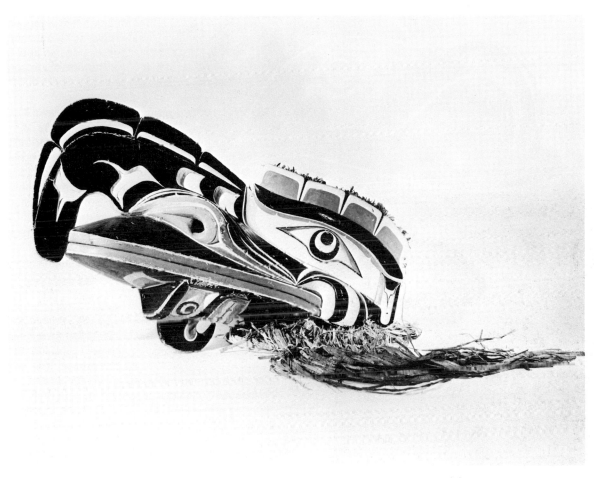

1. Kwakiutl Crooked Beak Mask

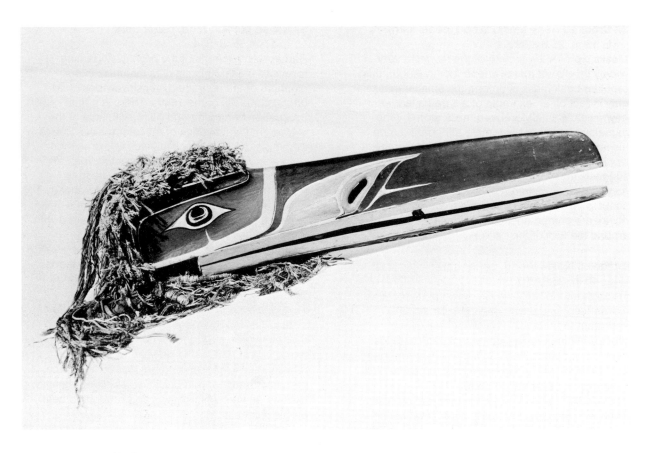

4. Kwakiutl Raven Mask

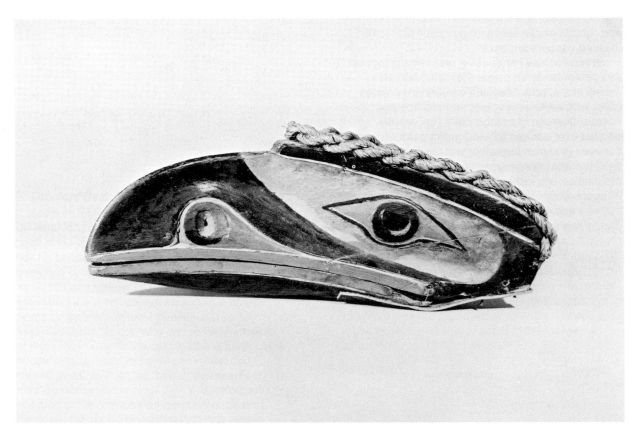

5. Kwakiutl Raven Mask

6. Kingfisher Mask. Wood. H. 21 in. 25.0/309

A number of dance complexes other than the *hámatsa* series are included in the Tséyka. The most spectacular of these in terms of the number and variety of masks used is the *atlákem*. In its most complete form it involves forty masked dancers who appear one by one at the call of the leader until all forty are dancing at one time around the fire of the dance house. Many of the masks represent animals, while some depict certain trees, bushes, mossy rocks, and even a midwife, a woman giving birth, and her children. The leader is most commonly the grouse, but raven and wolf are the leaders in some versions. As in the *hámatsa* series, the *atlákem* is an inherited privilege, recalling the adventure of an ancestor who came upon the assembled creatures dancing and was given the dance and all its paraphernalia as a supernatural treasure. His heirs reconstruct the event in succeeding generations.

Each dancer imitates the actions of the creature he represents in his performance by the movements of his body and head, and by conventionalized hand motions. The kingfisher dances with a high-stepping prance, his arms outstretched and head looking downward in the attitude of the hovering bird. From time to time he drops suddenly to a low crouch, suggesting the bird's dive after a fish in the water. Then he rises and continues his dance.

The mask represents the kingfisher in human form, with the bird-kingfisher's head and wings over the forehead. One of the more recent masks in the collection, it was carved within the last ten years by Henry Hunt, a prominent Kwakiutl carver. This mask was not made for use in a dance but was intended for sale, although it conforms to the characteristics of masks made for the "Animal Dance" claimed as a privilege by Mungo Martin, Henry Hunt's father-in-law and teacher. The use of natural cedar color for the background is a conscious return to older style Kwakiutl practice, away from the white painted backgrounds typical of Kwakiutl work from the last years of the nineteenth century until recently. The bold, clean planes of the carving and the design elements painted in black and red resemble the style of Mungo Martin's work in his later years.

7. Human Face Mask. Wood, cedar bark. H. 9 in. 25.0/310

The identification of this mask is uncertain, but the long fringe of red-dyed shredded cedar bark decorating it leads to the conclusion that it belongs to the Winter Ceremonial. It is very likely another of the many beings represented by masked dancers in the *atlákem*. The modeling of the features, with sharp definition of the eyesocket and deeply grooved cheek line, together with the white painted background and green eyesockets, clearly proclaim Kwakiutl origin. Also characteristic of Kwakiutl work are the red nostrils and lips and black eyebrows, eyes, mustache and cheek decoration, but these features are handled in a similar way over much of the northern coast. Although the mask is a strong and expressive example of Northwest Coast carving, the finish is rough and suggests a piece made hurriedly and intended to be used for a limited time. Interestingly, there is a tradition of destroying certain kinds of masks after using them a limited number of times, and the *atlákem* is one of the performances of which this was said to have been typical. George Hunt wrote of the Rivers Inlet *atlákem* dance: "And when they finish the last dance the last night, they put them on the fire in the middle of the dancing-house. The ones who use them put them on the fire. Therefore the white people can not get them" (Boas 1921:1219–20). That this custom was not always carried out is attested to by the fact that numbers of the masks are in museum collections.

8. Mask of a Female Face. Wood. H. 9½ in. 25.0/224

This small mask representing a female with parted hair was made to fit a child. It was worn by one of the children of the "Woman Giving Birth" in the *atlákem* dance. As in the case of the preceding mask, the workmanship is rather rough, but the modeling is direct and bold, and the typically Kwakiutl painting in strong colors contrasting with white background contributes to the effect of great vitality.

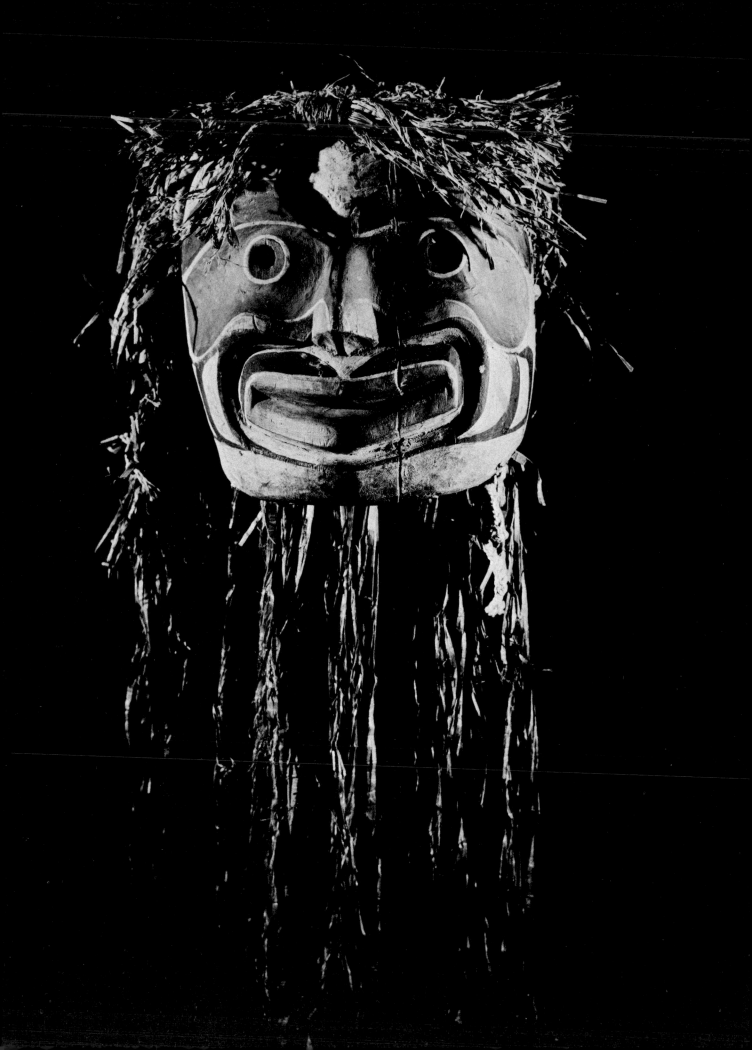

Other Tséyka Material

9. **Neck Ring Ornaments.** Wood.
L. 9 in., 10½ in. 25.0/232a,b,c

Tséyka participants all wear head rings and neck rings of red-dyed cedar bark unless they are performing in regalia that precludes the wearing of these articles. Some are simply strips of the worked bark tied around the head or hung over the neck and shoulders while others, depending in the old days on the symbolism required, are elaborately constructed of spun cords and ropes of bark intricately twisted, braided, and otherwise fashioned into the finished regalia. Sometimes other materials such as abalone shell, ermine skins, and carved and painted wooden appendages are combined with the basic cedar bark. At one time each of these details related to the tradition of the wearer, but today most of this sort of symbolism has been forgotten.

The neck ring ornaments in the Gerber Collection consist of a set of three carved and painted wooden plaques, representing the tail and flippers of a whale. There may have been a fourth piece representing the whale's head in the set. They were probably sewn to a ropelike ring of dyed cedar bark, perhaps 18 inches in diameter, which could be conceived of as the body of the whale. The bifurcate tail with a humanoid face for the joint hangs down the back of the wearer, while the two similarly decorated flippers stand out to the sides of the chest. While the concept is an old one, the style of the design and the commercial paint and varnish finish are recent characteristics. The set is signed "Charles George, Pt. Hardy, B.C." This is probably Charles George, Jr., formerly of Blunden Harbour and one of the best of the later practitioners of the Blunden Harbour style of Kwakiutl art. The artist consistently refrains from white background painting, considering the natural color of the wood to be a more ancient Kwakiutl characteristic (personal communication from the artist).

7. Kwakiutl Human Face Mask

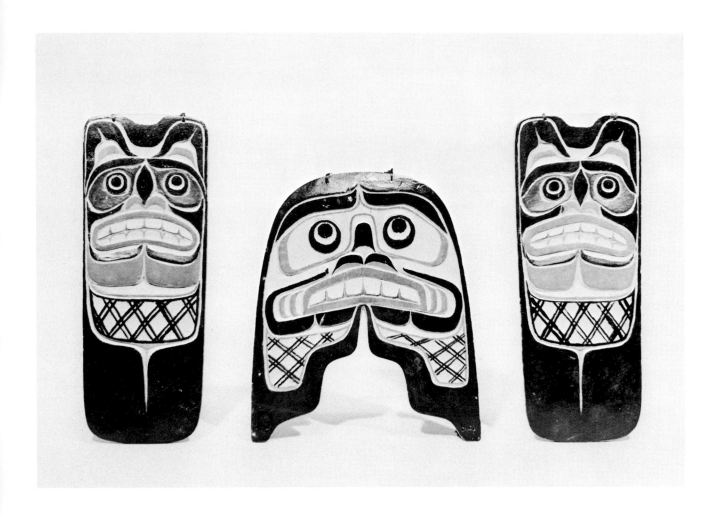

9. Kwakiutl Neck Ring Ornaments

10. Whistle. Wood. L. 9½ in. 25.0/263

The presence of supernatural power is expressed in some of the Tséyka performances by the sound of whistles. The *hámatsa* in particular is known by his whistles, which his attendants blow surreptitiously whenever the power of Bákhbakwalanoóksiwey becomes strong in him. His first approach to the village after his long absence, supposedly at the house of the cannibal spirit, is heralded by the eery sound. Whistles are held secret and are never intended to be seen in use. A bloody massacre, leading to a war ending in the capture of a canoe-load of chiefs not involved in the original incident, who were killed and had their privileges taken from them, is said to have followed the theft of a Winter Dance whistle. Most whistles used in the Tséyka have a mouthpiece similar to that of a recorder, and many are made with more than one windway and chamber so that two or more "voices" can be sounded at once. Two-voiced whistles, such as this one, are the most common of the multitoned whistles.

11. Whistle. Wood. L. 12⅝ in. 25.0/264

Very similar in construction to the preceding whistle, this one is rectangular in section and made of three pieces of wood bound together with cotton cord to form two chambers. In addition it exhibits carving in the form of faces whose mouths form the openings of the whistle mouthpiece. A number of whistles and flutes from various parts of the Northwest Coast with this decorative convention are known. Since these whistles were never meant to be seen by the audience, the fine finish and decoration require some other justification. Certainly the artist's satisfaction with a well-finished and designed object was a factor, and the ceremonial nature of this kind of object may have been an inspiration. The Kwakiutl do not distinguish between decorated and undecorated whistles, and there is no concept of one being more highly regarded as a ritual object than the other, although well-conceived and executed decoration is admired.

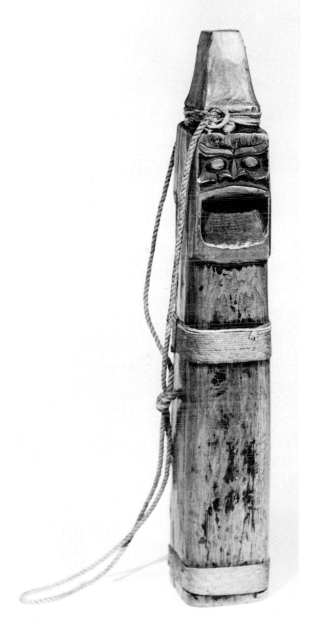

11. Kwakiutl Whistle

23

12. Whistle. Wood. L. 11⅞ in. 25.0/265
Another very well-finished *hámatsa* whistle
depends for its decoration upon a simple color
change from the natural wood mouthpiece to
dark brown or black painting over the remaining
surface, and sensitive shifts from sharp to rounded
corners of its square cross-section. The three
pieces of hardwood, perhaps yew, are fastened
together with four tight bindings of commercial
seine twine (one of which is missing), which
themselves become a part of the decoration. One
of the whistle openings is far down the barrel
of the whistle, resulting in a very short chamber
and a corresponding higher pitch, so that the two
voices are very different from each other. Some
whistles are purposely made with the two voices
nearly, but not quite, of the same pitch so that a
pulsating note is produced.

13. Double Whistle. Wood. L. 8½ in. 25.0/266
This whistle is unusual in that it combines two
completely different sound-producing mechanisms.
A single-chambered whistle similar to those already
described is joined by lashing to the mouthpiece of
a vibrating reed whistle. The two voices produced
contrast in pitch and quality, one being a clear
flutelike note and the other a buzzing or squealing
tone. Whistles widely varying in size and pitch
as well as in tone quality were used to represent
the presence of certain of the spirit motivators
of the Winter Ceremonial. This whistle belongs to
the Tséyka version of the Bukwús ("Man of the
Ground").

14. Triple Whistle. Wood. L. 16 in. 25.0/267
In this *hámatsa* whistle the three different voices
are produced by three separate cylindrical whistles
bound together so that their mouthpieces join and
their barrels radiate out in a fanlike configuration.
This is another example of the variety of whistles
used in the Tséyka.

15. Singer's Baton. Wood. L. 14 in. 25.0/268
The Kwakiutl use no melodic instruments except
the voice. The whistles blown during the Winter
Ceremonial produce only single notes. They are
thought of as musical instruments, but as a means
of producing sounds that represent the presence
of supernatural power or the voices of the creatures
represented in the dances. The only others used
are percussion instruments, which are ordinarily
used to accompany songs. The singer's baton or
túmyaiyoo (rhythm instrument) is the principal one
of these. This is, in its simplest and most common
form, a rough stick a foot or more long split from
a block of firewood and with the handle end
smoothed with a knife to form a comfortable grip.
The singers sit at the back of the house before
the painted screen which forms the secret room
for the dancers. They are in two rows, facing one
another across a plank or log upon which they
beat time with their batons. The song leader, who
is seated near the middle of the chorus, may have
an elaborately carved and carefully finished baton
of hardwood like this one. These are said to have
been common at one time, but they are very rare
today and are practically never seen in actual use.

The design carved on this baton probably
represents the Thunderbird, which may have been
a crest of the owner, although the significance of
the designs on batons is not clear. Many of them
are decorated to represent the sea lion, an animal
whose form is easily adaptable to the shape of the
instrument. This Thunderbird carving may be the
work of Willie Seaweed, late chief of the
Nákwakdakw tribe of Blunden Harbour and one of
great Kwakiutl artists of all time. The shallow relief
carving is carefully done, and the design is
beautifully integrated with the swelling form of the
baton. The hardwood from which it is carved has
been finished with a coat of shellac or varnish,
a modern touch. It was probably made early in the
present century.

16. Singer's Baton. Wood. L. 13¼ in. 25.0/269

Although very similar to the preceding *túmyaiyoo* and also decorated with an incised Thunderbird, this baton shows a somewhat tighter pattern. The decoration in both cases is a good example of the Kwakiutl version of the northern style of two-dimensional decorative art which apparently reached the Queen Charlotte Strait people in relatively recent times, perhaps early in the last century. Freer and less rigidly conventional than its highly sophisticated northern counterpart, this art has nonetheless produced pieces that rival the subtle richness of northern work, as can be seen in batons like this one, with its finely engraved lines bordering formlinelike patterns, and the sensitively modeled shallow relief.

Singers' batons are for vigorous use, and the elaborately carved ones are made of hard, tough wood to withstand the punishing battering they get during the long nights of singing. Fifteen or twenty of them striking out the driving syncopated rhythm of a Winter Dance song on a resonant log can move almost anyone to dance. With the deep-throated singing of the chorus and the accompanying bass pulse of the box drum, or more recently the conventional bass drum, they provide a moving musical experience.

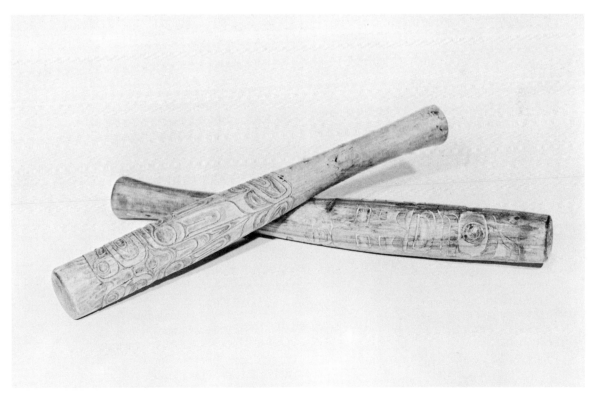

15,16. Two Kwakiutl Singer's Batons

17. Ceremonial Rattle. Wood. L. 12 in. 25.0/290
From the ritual standpoint, the most important musical instrument in Kwakiutl ceremonial use is the rattle. Rattles are made in several distinct types, and round or ovoid examples such as this one are typically used in the Tséyka. Shamans' rattles of the Kwakiutl and more northerly tribes are often of this type, and since the participants in the Tséyka are referred to as "Shamans" (Pépakhula), the similarity in rattle form is understandable.

The sound of the rattle is a direct contact with the supernatural. In the highly formalized Kwakiutl Winter Ceremonial, with its emphasis on prerogative display, the action that most clearly evokes a memory of the ancient religious background of the ritual is the rattle-accompanied singing of the ritualist, calling down the spirits of the Winter Ceremonial, bringing in the red-dyed cedar bark, calming the wild *hámatsa*. All dancers' attendants carry rattles with which they announce the approaching entrance of the dancer and which they constantly swing to honor and calm the performer, who is theoretically susceptible to possession by the supernatural being motivating his dance.

A stylized face, resembling in some respects the designs on many northern rattles, is carved in shallow relief and painted in white, black, red, and green on the curved surface of this rattle. The painting, in a very typical Kwakiutl color scheme, is done with commercial paint. The rattle is nicely made and decorated and is a good example of the recent ceremonial art of the Kwakiutl.

18. Clapper. Wood, leather. L. 9 in. 25.0/270
The clapper is something of a combination of rattle and *túmyaiyoo*. It is held in one hand and shaken like a rattle, but the sound is produced by two pieces of wood striking together. It is shaped somewhat like a rattle, with a cylindrical handle extended into an oval sound chamber made of two hollowed pieces of hardwood. The juncture of the handle and sound chamber is made thin and flat so that the two halves will snap together when the clapper is shaken. In some examples, such as this one, the upper half of the chamber is hinged to the handle with a thin strip of leather. The whole instrument is carved and painted to represent the killer whale, and a thin upright dorsal fin and pectoral flippers of wood have been added to heighten the resemblance.

Among the Kwakiutl the use of the clapper is reserved to the Mítla dancer, one of the performers in the Tséyka series. In the dance it is shaken rapidly and produces a staccato clattering sound.

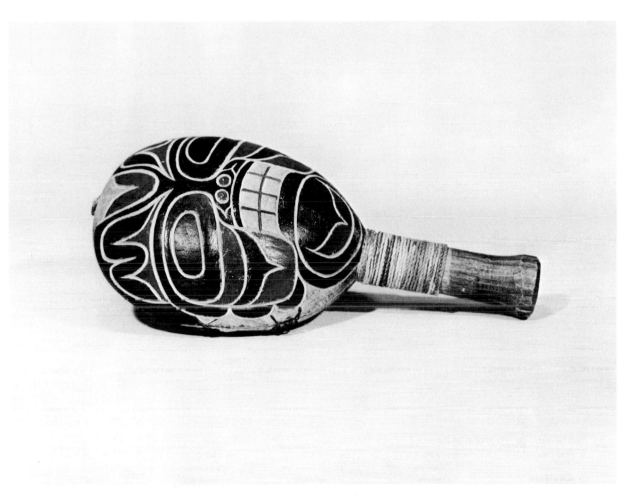

17. Kwakiutl Ceremonial Rattle

The Tlásulá

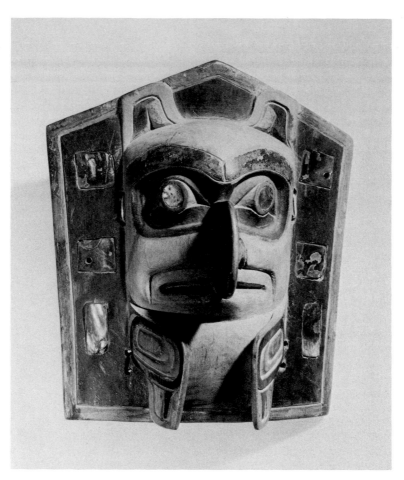

19. Kwakiutl Headdress Frontlet

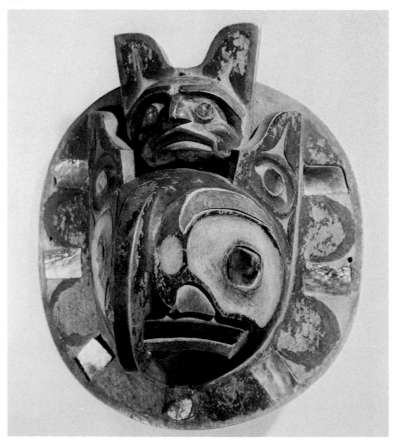

20. Kwakiutl Headdress Frontlet

19. Headddress Frontlet. Wood, abalone shell.
 H. 7 in. 25.0/233

Present-day Kwakiutl, in speaking English, use the
terms "Weasel Dance" or "Feather Dance" in
referring to the Tlásulá cycle. Both of these refer
to the use of the headdress of which this frontlet
is a part. In its complete form the frontlet, which is
carved of hardwood such as maple and inlaid with
blue-green abalone shell, is sewn to a cylindrical
crownlike headdress. The carving rests on the
dancer's forehead, giving the headdress its
Kwakiutl name *yukwíwey* (dancing forehead mask).
The back of the headdress is usually covered with
a strip of swanskin from which the feathers have
been plucked, leaving the thick, luxuriant pure
white down. Around the upper rim is attached an
upright row of the whiskers of the bull Steller sea
lion or, lacking that material, thin splints of
amber-colored whale baleen. To the back of the
crown is appended a long, wide panel of cloth on
which are hung, shingle fashion, rows of white
ermine (winter weasel) skins. When the dancer
performs, arrayed in ceremonial blanket, apron,
and headdress, a considerable quantity of white
eagle down is placed within the "fence" of
sea lion whiskers. As he bobs his head and jerks
it from side to side, fluffy bits of down are released
and wafted around the dancing figure by the
currents stirred by the whipping whiskers. When
several dancers perform together, they produce a
veritable snowstorm of down, which fills the air
and drifts about the floor of the dance house.

The carvings on the frontlets are apparently
family crest figures, but the headdresses were so
frequently a part of potlatch distributions that the
individual significance has usually been lost. All the
tribes from the Kwakiutl northward made and used
the dancing headdress, and many now in use by
the Kwakiutl have their origins on the northern
coast. This example is certainly Kwakiutl, however,
judging by the stylization of the carving and
painting. The figure is a hawk or thunderbird with
folded wings. The slightly flared rim with its gabled
upper edge and inlay of small separated pieces
of abalone shell is typical of southern Kwakiutl
frontlets. Several of the inlaid pieces are pierced
with small round holes, a sign that the abalone
shell was salvaged from previous use on a
blanket or other decorated article.

20. Headddress Frontlet. Wood, abalone shell.
 H. 7¼ in. 25.0/231

Although collected among the Kwakiutl, this
frontlet is apparently of Bella Coola manufacture.
The circular rim is fairly frequently seen on frontlets
from all parts of the coast. The representation here
is of the killer whale. A beaklike ridge running
down over the upper lip is a stylized feature of
the killer whale in Kwakiutl and Bella Coola
carvings. The small human face modeled with
intersecting convex planes in the Bella Coola
style forms the joint of the double-fluked tail at
the top of the frontlet, flanked by the whale's
flippers. The Northwest Coast artist's ability to
reduce an animal to its essential features and
compose them in a restricted space is beautifully
illustrated in this classic Bella Coola dancing
headdress. A rich cobalt blue is the predominant
color, with details of the lips and nostrils painted
in vermilion, the eyebrows black, and the
eyesockets of the killer whale in green.

21. Raven Rattle. Wood. L. 14 in. 25.0/237

A carved wooden rattle in the form of a raven carrying a figure of a man on its back, and with the breast and tail elaborated into birds' heads, is the proper form used by headdress dancers throughout the northern coast. Most of them were made by artists of the Tlingit, Tsimshian, and Haida, and there is some traditional evidence suggesting a Tsimshian origin for the concept. The form was so standardized, however, that raven rattles from the whole coast have most features in common, and one must look to subtle differences in the handling of detail to identify the place of origin. This rattle appears to be of Bella Bella or Owikeno make. The details are painted in black, vermilion, and a rich blue and carved in shallow relief. On the reclining man's chest crouches a frog (frequently seen in this position on raven rattles). It is caught in the beak of a bird, perhaps a kingfisher, whose head crest feathers form the tail feathers of the raven. The frog holds the tip of the man's tongue in his mouth. The meaning of this feature, a common theme in Northwest Coast Indian art, is not clear although it has often been described as symbolizing a transfer of power from one figure to another. On the raven's breast a formline design depicting the face of a hawk or thunderbird, with a beak sharply curved back to the lips, has been painted and carved. This is an invariable feature of the northern raven rattle.

There has been considerable speculation concerning the origin and meaning of these standardized figures. According to one myth the rattle appeared in its complete form supernaturally. Some stories appear to have been made up in attempts to explain the rattle's complex form.

During certain versions of the headdress dance, the raven rattle is held in the outstretched hand and shaken continually during the performance. Most northern dancers hold the rattle upside down, with the breast-bird looking upward. There is a tale of the loss of a rattle which came to life when it was held upright and flew away through the smoke hole in the roof of the house.

Although the raven rattle has often been described in the literature as a medicine man's instrument, Indians throughout the coast area consider it to be a chief's dancing rattle.

22. Horn. Wood. L. 10¾ in. 25.0/262

The approach of the supernatural power motivating the Tlásulá dance is represented by the sound of cedar whistles or horns which differ from those of the Tséyka in that the sound is produced when the thin sides of the mouthpiece vibrate together. The sound resembles that of a reed horn or klaxon. The new dancer who is about to be initiated (that is, for whom the Tlásulá mask is to be shown) enters, wearing the dancing headdress. His song commences, and he begins to dance. At this point he is considered to be very susceptible to spirit possession, and his attendants, instead of guarding against his losing self-control, tease and torment him. They mimic his dancing or dance along behind him under the ermine trailer of the headdress. The new dancer can tolerate these annoyances for only a short time before he loses control and rushes out of the door of the house with his attendants in pursuit. Very soon they reappear, carrying the headdress and blanket of the missing dancer. A lively discussion ensues, with much conjecturing as to the whereabouts of the dancer. The attendants sometimes try, ineptly, to carry on in the dance. Today the whole atmosphere during this byplay is lighthearted and even comic, although it may have been more serious in other times.

Suddenly the horns are heard from outside the house, signaling the return of the novice dancer in the form of a supernatural being. The attendants fearfully and very reluctantly investigate. Finally they bring in a masked dancer, impersonating the creature who figures in the origin myths of the dancer's family.

Many Tlásulá horns are carved with designs that probably relate to the meaning of the mask with which they are associated. The highly conventionalized design on this example represents a bird, perhaps a thunderbird. The two halves of the hollowed cedar shell are bound together with red cotton string, and the design is carved in low relief and painted in white, black, orange, and blue.

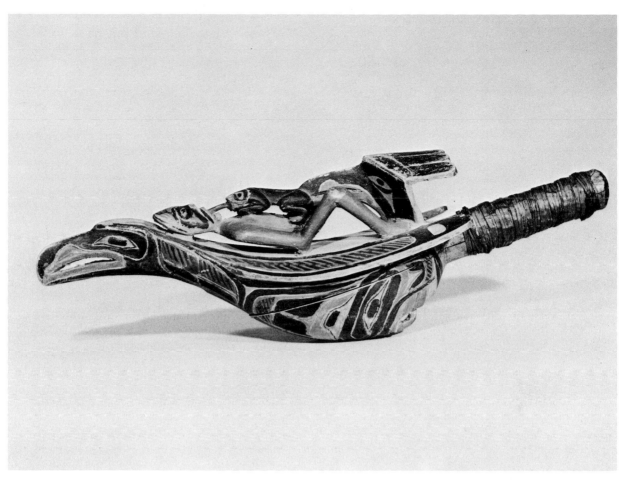

21. Kwakiutl Raven Rattle

23. Horn. Wood. L. 17¼ in. 25.0/260

Tlásulá whistles and horns vary in size from small squeakers held in the dancer's mouth or built into the mask to rather large instruments nearly a yard in length. This horn, one of a pair in the Gerber Collection, is about average in size. The plain brown cedar is decorated with an unpainted relief carving of fine quality, representing a raven. The figure is highly conventionalized and very closely resembles the sophisticated formline surface decorations of the northern coastal artists.

The construction is extremely simple. A bottle-shaped billet of cedar is split, and each half is hollowed. The two pieces are placed together and joined by a simple wrapping of string around the large open end. The small end, somewhat flattened, is held in the mouth and blown, causing the thin sides to vibrate. This produces a deep and penetrating note which can be varied in a harmonic series by overblowing or by pressure on the mouthpiece with the lips.

24. Horn. Wood. L. 17½ in. 25.0/261

The second horn of the pair also bears a relief carving of a raven in the same style and of the same quality as its mate. The raven, however, is represented with a broad humanoid face, the beak extending downward from the lower jaw. The horn is almost identical in size and form to the other.

These horns are sometimes designated as from the Dluwúlakha ritual. The terms Dluwúlakha and Tlásulá appear to be interchangeable. George Hunt wrote in Boas' *Kwakiutl Tales,* "LasEla means the ḷEwElaxa" (Boas 1935:88), but Tlásulá seems to have survived while Dluwúlakha, the Bella Bella name common at the turn of the century, has gone out of use and is not even remembered by many Kwakiutl today.

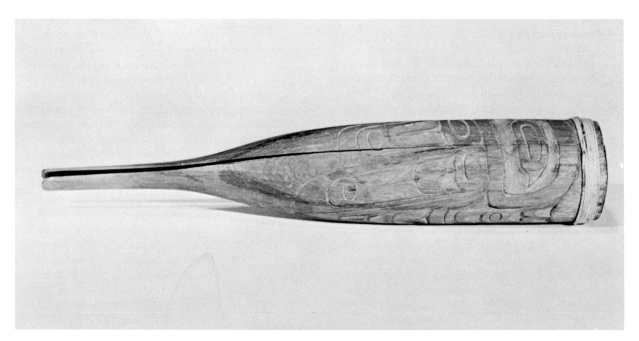

23. Kwakiutl Horn

Tlásulá Masks

25. **Dzoónokwa Mask.** Wood, human hair.
H. 13 in. 25.0/218

Of all the mythical personages represented in Kwakiutl art, perhaps the best known, and the one that best epitomizes the powerful, semihuman, supernatural beings who people that art and tradition, is the Dzoónokwa. Usually represented as a female (male Dzoónokwas are mentioned in some stories), she is a giantess with great strength and awesome appearance. Her characteristic features are large size, dark hairy body, hanging breasts, and a great head with heavy brow, arched nose, sunken cheeks and eyesockets, and—most important—lips pushed forward and rounded to produce her fearsome cry, "Oooooh!"

Stories of the Dzoónokwa range from tales apparently designed to impress children with the importance of correct behavior to important family myths explaining the origins of valued prerogatives. The Dzoónokwa is frequently represented on house posts and totem poles, in feast dishes, and in masks. She is thought of as an object of fear, but at the same time a source of wealth and power. Some of this special attitude of awe of the Dzoónokwa may be related to the fact that many Kwakiutl consider her to be in a somewhat different category from most other supernatural creatures represented in art and ritual. Most of these creatures are conceded to be fictional, or at least to have disappeared from man's earth in times past. Dzoónokwas, on the other hand, are commonly believed to exist today, but generally away from the habitations of man—fugitives, according to some informants, from the air and noise pollution introduced by the gasoline boat engine!

The Dzoónokwa may appear in either the Tlásulá or the Tséyka, depending upon the origin of the dance privilege. The mask in the Gerber Collection is, strictly speaking, part of neither, but certain chiefs had the right to display it when they were asserting their rank and wealth. This is most apt to happen when the owner of the mask feels threatened and intends to break a copper to uphold his family's honor. For this reason the *gyíkumhl* ("chief's mask," as this sort of Dzoónokwa mask is called) represents the fearsome aspect of the monster. Some of these masks are anatomically realistic, giving the wearer the appearance of a real creature as he shouts the Dzoónokwa's cry through the everted lips. Painted black with powdered graphite (except for red lips, cheeks, and nostrils), with a tangled mane of human hair and often bushy eyebrows, mustache, and beard of black bear fur, the Gyíkumhl is calculated to be frightening. Nail holes in this example indicate that it was once fitted with fur eyebrows. It is painted red and graphite black in the traditional manner, and was carved by George Walkus, a well-known artist of the Gwásila tribe of Smith Inlet.

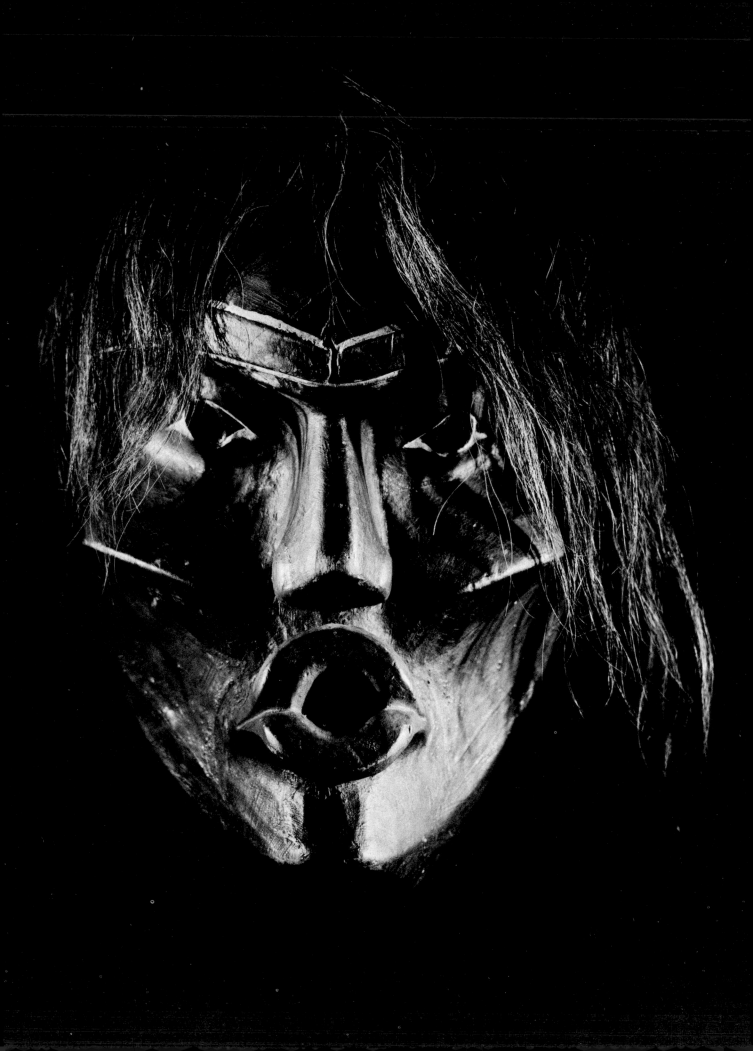

25. Kwakiutl Dzoónokwa Mask (two views)

26. Gyídakhanis Mask. Wood. H. 12 in. 25.0/222

After the disappearance of the excited headdress dancer and the sounding of the Tlásulá horns announcing his imminent appearance, the attendants usher in a dancer, or a group of dancers, whose function is to display the inherited privilege toward which the whole Tlásulá dance is focused. If it is a single dancer, he may be conceived of as being the former headdress dancer supernaturally transformed into a creature central to a family myth. Some dances, such as the Gyídakhanis, feature groups of dancers and are re-enactments of mythical incidents or dances acquired from supernatural contact by an ancestor.

The Gyídakhanis dance (or Ádakhanis as it is called in some Kwakiutl dialects) is said to have been acquired as a dowry in mythical times from a Tongass Tlingit chief (Gyídakhanis is actually a Tsimshian term for the southern Tlingit). The dancers represent seven slaves and their chief or, in some versions, a family, including children. Each wears a face mask, the chief's being larger than the others. In the dance he leads the others, wrapped in his blanket and haughtily strolling around the floor. The other seven perform a lively and difficult dance with knees bent in a half-crouch, posturing in time with the rhythm of the song. They may carry in their hands white eagle tails which they use to accentuate their gestures. The dance is in imitation of the Tlingits, who do a similar dance which they consider to be derived from the Athabaskans of the interior.

Gyídakhanis masks are usually painted white with eyebrows, eyes, and mustaches in black and lips and nostrils in red. There may be, as in this one, other painted decoration on the cheeks and in the eyesockets. Another characteristic is a round hole drilled through the top of the forehead. A stick to which a plume of small feathers has been tied is stuck upright in the hole. Perhaps this relates to the Tlingit custom of wearing plumed sticks in the headband in the "Athabaskan" dance. Chinese featherdusters of maroon-dyed rooster hackles are the usual Tlingit choice. Some atlákem masks also have holes in the forehead for the attachment of special decorations, so the hole is not in itself a conclusive characteristic.

27. Gyídakhanis Mask. Wood. H. 10¾ in. 25.0/311

Another painted face mask in the Gerber Collection similar in design and expression to the previous mask may be for the Gyídakhanis dance. The eyesockets are painted green, and there is formlinelike painting on the cheeks and forehead. The eyebrows, eyes, and mustache are black and nostrils and lips red in the usual arrangements. Part of the background is painted white. The lips are rounded and slightly open, suggesting an animation in keeping with the movements of the dance. Except for their chief, who stalks around rather than dancing, the Gyídakhanis dancers do not ordinarily wear blankets. Today they wear a dancing apron over their everyday dress. In times past they may have imitated the dress of Tlingit dancers.

28. Gyídakhanis Mask. Wood. H. 10 in. 25.0/315

Like the previous mask, this one differs from many Gyídakhanis masks in its lack of full white background paint, but its other characteristics— size, animated expression, and the hole in the forehead—suggest it may be from that performance. The white paint and the mustache on many masks has led to their identification as representations of white men, but there is in fact no such intention. Almost all Northwest Coast Indian masks representing human males show a mustache, and often also a small beard on the point of the chin. Early journals frequently mention that Indian men of the region wore beards and mustaches, and they were certainly common all during the period when these masks were being made.

The characteristic Kwakiutl use of green paint in the eyesockets is seen here as well as the customary painting of the features. A red formline design is painted on each cheek and merges with the red nostrils.

29. Gyídakhanis Mask. Wood. H. 10 in. 25.0/317

The quality of design and workmanship varies widely in Kwakiutl masks. This one was one of a set of six Gyídakhanis masks purchased by Sidney Gerber from its Indian owner in Blunden Harbour, B.C. The other five in the set are much superior to this mask, although this one is probably older than the others. It has been repainted white over an older painting and has the usual black eyes, eyebrows, and mustache, with traces of red around the nostrils —perhaps a remnant of the earlier painting. Masks were often repainted, either to brighten them up after use had dulled the colors or to change the character of the mask, as appears to have been the case here. Very often the later painting detracts from the quality of the mask, because of inferior workmanship or the second painter's failure to integrate the painting properly with the sculptural form.

30. Gyídakhanis Mask. Wood. H. 11 in. 25.0/316
Examples of Northwest Coast Indian artwork can often be identified as to tribal origin by characteristics of form and iconography. By the same means it is sometimes possible to recognize the work of specific individual artists. One of those whose work is most easily identified is Willie Seaweed. One of the great Northwest Coast artists, he was born about 1875, and his career as an artist spanned over half a century. When he died in 1967 his works included dozens of masks, totem poles, rattles, and every kind of object produced by Kwakiutl artists. None ever surpassed his work in its precisely conceived and executed design.

This mask was made by Willie Seaweed as part of a set for the Gyídakhanis dance. The most obvious Seaweed features are the precision and clarity of the planes of the face and the clean, meticulous painting. The intense, animated expression and satisfying proportions are equally characteristic of his work.

The mask is painted a solid white with commercial paint. The tiny precise mustache, round eyes, and arched eyebrows of typical Seaweed conformation are in glossy black, while the lips and nostrils are in red.

31. Gyídakhanis Mask. Wood. H. 12 in. 25.0/318
The face of this mask, another one from the same set as the previous mask and also the work of Willie Seaweed, expresses an entirely different personality. The best Gyídakhanis masks have this kind of individuality so that the dancers present a lifelike variety although the masks are not really naturalistic. The heavy drooping eyebrows and mustache, open mouth, and staring eyes suggest a naïveté not seen in the shrewd expression of the first mask. The face is entirely white, with the features in black and red. Each part is designed in terms of its own form and its relationship to adjacent forms and the whole mask. It is a highly intellectualized piece of sculpture, typical of the work of Willie Seaweed in every way.

32. Gyídakhanis Mask. Wood. H. 11 in. 25.0/319
Although from the same set and stylistically like the others, this mask and the one following were made by Joe Seaweed, working with his father, Willie. It would probably be impossible to distinguish from his father's work on stylistic grounds alone, and there was certainly an effort on the artist's part to make the mask appear to be related to its mates. Again the character expressed by the little smile and drooping brows is unlike that of the others, suggesting innocent—perhaps even gullible—wonder.

33. Gyídakhanis Mask. Wood. H. 12 in. 25.0/320
The second Joe Seaweed mask also resembles his father's work in many ways, and again it suggests an individual personality. It is probably unwise to interpret the expression on most Northwest Coast sculptured faces, animal or human, since the conventions of sculpture frequently had a greater influence on the set of the features than any expression intended by the artist. In the case of the Gyídakhanis, however, it seems clear that the artists intended the Tongass slaves to be individuals with their unique personalities. This one expresses what might be surprise and delight, with raised brows and round, open mouth.

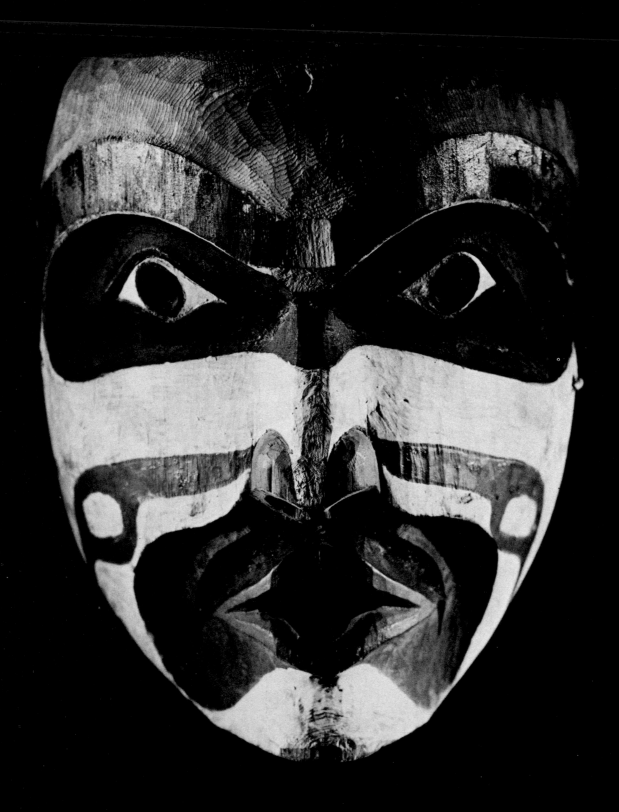

28. Kwakiutl Gyídakhanis Mask

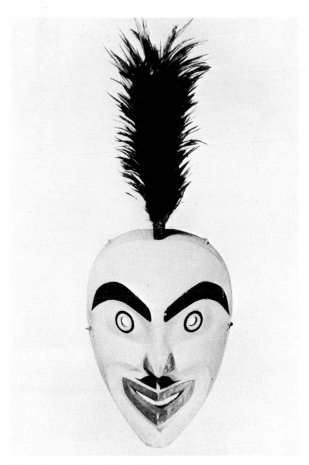

30. Kwakiutl Gyídakhanis Mask

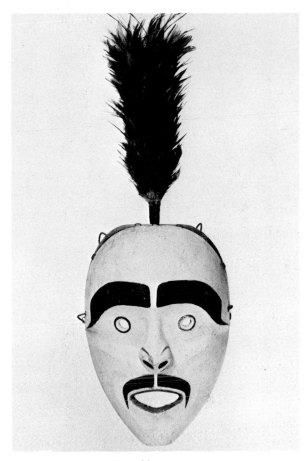

31. Kwakiutl Gyídakhanis Mask

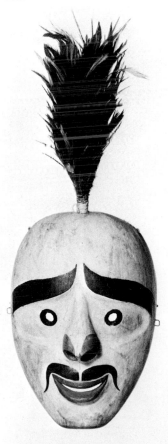

32. Kwakiutl Gyídakhanis Mask

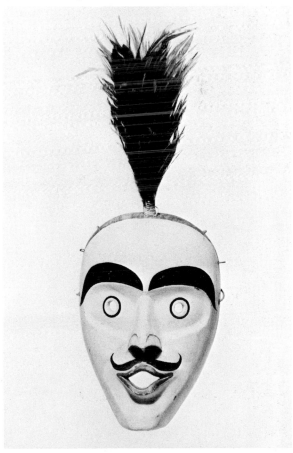

33. Kwakiutl Gyídakhanis Mask

39

34. Earthquake Mask. Wood. H. 9 in. 25.0/313

Although the characteristics of this mask are not distinctly those of typical Kwakiutl representations of the personified earthquake, there seems no real reason to doubt the identification indicated in a penciled inscription inside the mask. It was collected at Blunden Harbour, one of the most northerly of the Kwakiutl villages, which has natural contacts with the Owikeno and Bella Coola to the north. The configuration and painting of this mask reflect Bella Coola influence, although it is probably a product of a Nákwakdakw Kwakiutl carver. It is painted in black, red, and green on a natural wood background. The carving is bold and somewhat rough.

Many mythical creatures are represented in the Tlásulá dances, according to the traditions of the family displaying the privilege. The personified earthquake is one of these.

35. Gambler Mask. Wood. H. 11¾ in. 25.0/314

Another mask collected at the same time and from the same village by Sidney Gerber is also identified by a penciled inscription and, like the previous example, cannot otherwise be identified. It resembles even more certain Bella Coola masks and may in fact have come to Blunden Harbour from another area. Masks fairly frequently went from one tribe to another and often changed their identity to comply with the concepts of the new owners. Perhaps the expression and form of this mask suggested the characteristics of the conventional Kwakiutl "gambler mask," and thus it was identified and used as such. The large background area of unpainted wood is more Bella Coola than Kwakiutl in style, and the simple geometric pattern of red stripes resembles some mask painting of the former tribe.

The use of the gambler masks in a stylized performance of the widely known Hand Game or Bone Game as part of the Tlásulá is well described in Dr. S. A. Barrett's notes (Mochon, 1966:96–97). High-ranking guests are invited to play against the masked gamblers and are paid lavishly.

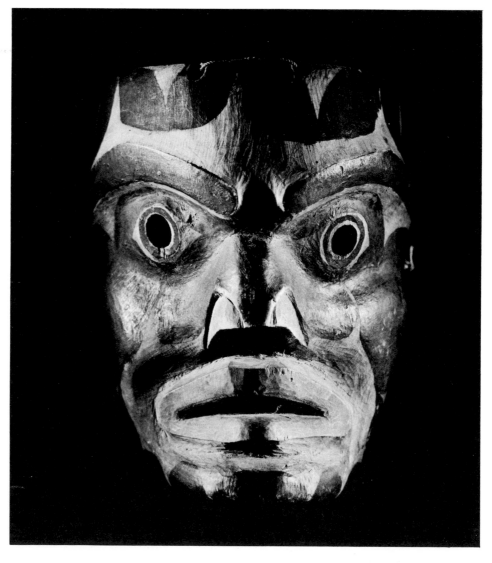

34. Kwakiutl Earthquake Mask

36. Bukwús Mask. Wood. H. 11 in. 25.0/220

A creature in many ways similar to the well-known Dzoónokwa and held by the Kwakiutl in somewhat the same regard is the Bukwús, generally translated by the Kwakiutl as "Wildman." "Man of the Ground" is perhaps a more literal translation of the native term. The Bukwús is thought of as a sometimes malevolent manlike being, a chief of the ghosts, whose habit it is to lure unsuspecting travelers into eating the food of the Bukwús thereby transforming them into beings like himself, or to take the spirits of drowned people into his retinue. Some present-day Kwakiutl believe that the Bukwús, like the Dzoónokwa, still inhabits wild stretches of the British Columbia coast and can occasionally be seen very early in the morning prowling the beaches in search of cockles, which he prefers to all other food eaten by humans.

Bukwús masks are characterized by deep-set eyes under a massive brow, a strongly arched or even hooked beaklike nose, small pointed ears, and lips either drawn back over exposed teeth or pursed forward. Some of them are frighteningly realistic while others depend for their lifelike effect on the expressive movements of the dancer and the play of firelight on the deeply sculptured features. The Gerber mask is of the second type and is similar to others from Blunden Harbour of the same early twentieth-century period. It is strongly carved and painted black, red, green, and white. The artist was Charlie George, Sr.

The dance of the Bukwús is among the most distinctive and demanding of Kwakiutl dances. The dress of the dancer in earlier days is described as a close-fitting buckskin suit, perhaps colored black. Today the Bukwús wears a black or brown coverall trimmed with horizontal rows of triangular white cloth appendages. His movements are alternately slow and active, and he frequently peers around the back of his upraised hand, which he holds to his cheek as if to shield his face from observation. A skillful dancer evokes the impression of an intense, inquisitive creature, surreptitious but with great strength and vitality. Joe Seaweed portrayed him perfectly in a fragmentary Bukwús dance in the film *Dances of the Kwakiutl* (Orbit Films 1951a).

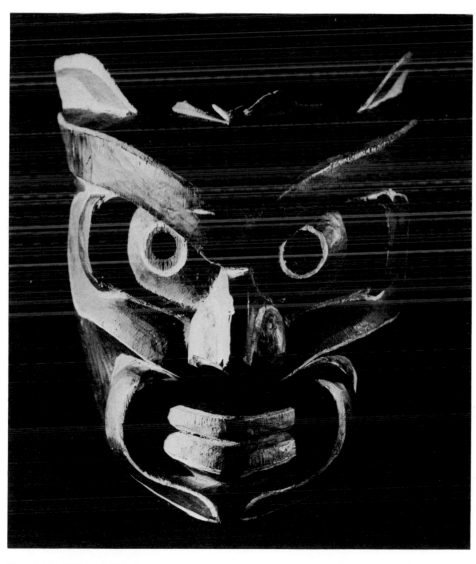

36. Kwakiutl Bukwús Mask

37. Face Mask. Wood. H. 15 in. 25.0/219

The penetrating gaze and lips drawn back, baring the teeth, suggest the Bukwús in this unidentified mask, but it lacks many features typical of that creature. Given the freedom of Kwakiutl artists and our superficial understanding of the native iconography, it is very risky to attempt to name masks that lack the most obvious identifying features.

This mask is unusual in that only black paint is used on the natural wood surface. The placement and form of the painted areas are, however, typically Kwakiutl.

38. Killer Whale and Sun Mask. Wood. H. 29 in. 25.0/227

Conceptually this large Tlásulá mask is not unlike the Bella Coola frontlet (No. 20) described earlier. The killer whale's large head with its down-turned snout and large white teeth occupies the center of a circular plaque almost two feet in diameter on which are painted the tail, flippers, and other body parts. The dorsal fin, a primary identification feature of the killer whale, stands over the creature's head, carved of a separate piece of wood mortised into the top of the mask. The circular plaque on which the carved parts are mounted suggests the sun. Such combined figures are common Kwakiutl masks as illustrations of mythical transformations or combinations of figures featured in the myth dramatized in the masked dance.

This piece by Willie Seaweed is representative of his earlier work. The painting of the whale's appendages on the sun disk are unlike typical Seaweed work and may even be by another artist, but the sculpture and painting of the head are early Seaweed without a doubt. His style is among the most distinctive and consistent of all Kwakiutl artists.

When it is used in a Tlásulá performance, the killer whale and sun mask appears following the disappearance of the headdress dancer. Moving with slow steps around the dance house, the blanketed mask dancer turns his head one way and another to display the great sun disk and killer whale glowing in the firelight amidst swirling white down blown by the attendants.

39. Sun Mask. Wood. H. 20 in. 25.0/228

The personified sun is usually shown in Kwakiutl art as a human figure with a hooked beaklike nose and a corona of decorated rays surrounding the face. The sun mask in the Gerber Collection—a recent work by Jack James, a Kwakiutl carver still active at Alert Bay—illustrates this conventional form. The entire surface has been underpainted in white, and the details of the decoration are in black and orange, a frequent substitute for red in James's work. With this exception the color use is entirely traditional. A narrow scalloped rim surrounds the face, and four broad flanges, decoratively carved and painted and representing the rays of the sun, radiate outward.

The mask was made for sale and is a good example of the better quality of work being produced today for the collectors' market by Northwest Coast Indians. Jack James, one of the most imaginative of the contemporary Kwakiutl carvers, is one of those who have for years produced masks and ceremonial objects for use by their own people and at the same time made similar pieces for sale to visitors to their villages or through dealers in Vancouver and Victoria. Masks by some of this group of artists, collected in years past from Indian owners, hold honored places in major museum collections of Northwest Coast Indian art.

40. Owl Mask. Wood. H. 10 in. 25.0/215

Sidney Gerber purchased this owl mask from Willie Seaweed shortly after it had been photographed, worn by Joe Seaweed, in the film *Dances of the Kwakiutl* (Orbit Films 1951a). As seen on the museum wall the round bulging eyes set in flaring blue-green sockets and the fierce hooked beak dramatically express the character of the nocturnal bird of prey. When it is worn in the dance, the bird gains life.

The mask is bold in its conception and execution. Made perhaps fifty years ago by George Walkus of Smith Inlet, it represents the artist's style at its most expressive. The painting in black, red, green, and white follows the carved features and elaborates the cheeks in typical Kwakiutl fashion.

41. Raven Mask. Wood. L. 24 in. 25.0/205

This small raven forehead mask resembles the *héyhliwey* used in the taming of the *hámatsa,* but knowledgeable Kwakiutl have identified it as a Tlásulá mask. The lack of red cedar bark and the presence of the wooden "coppers" over the eyebrows probably led to that conclusion.

The mask is nicely carved of red cedar and is very light in weight, owing to the thinness of the hollowed mask and the natural lightness of the wood. The painting is in the usual colors—black eyebrows, eye detail, and beak; red lips, nostrils, and cheek detail; green eyesockets; and white in various lines and negative areas. The narrow coppers over the brows are painted in the same colors on natural cedar. Many Tlásulá masks have articulated jaws, as does this raven. The jaw hinge is extremely simple. A single nail driven through each rear corner holds the jaw nearly closed, but allows it to spring open and shut with slight movements of the mask. No control strings are needed.

Forehead masks of this type leave the dancer's face exposed. Sometimes during the dance the blanket is raised with the forearms to cover the face, allowing the mask to peer over the blanket and heightening the illusion of a bird or animal.

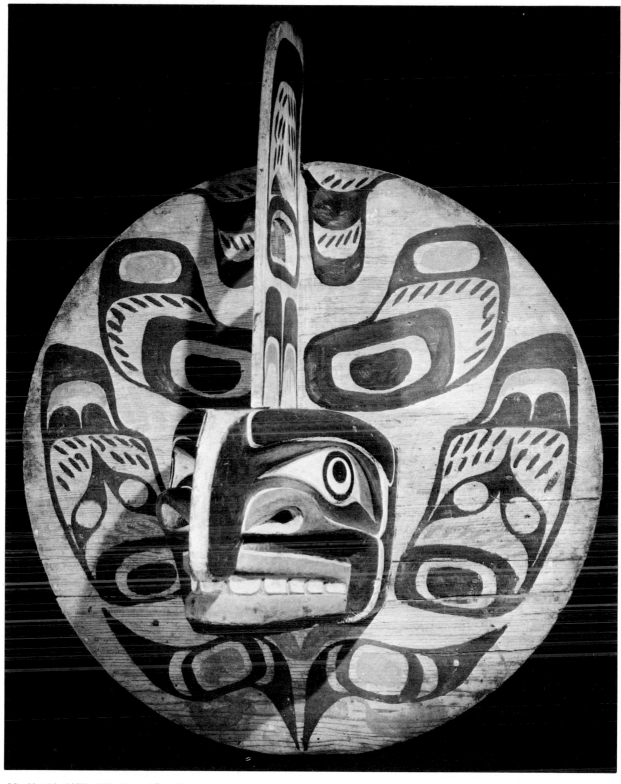

38. Kwakiutl Killer Whale and Sun Mask

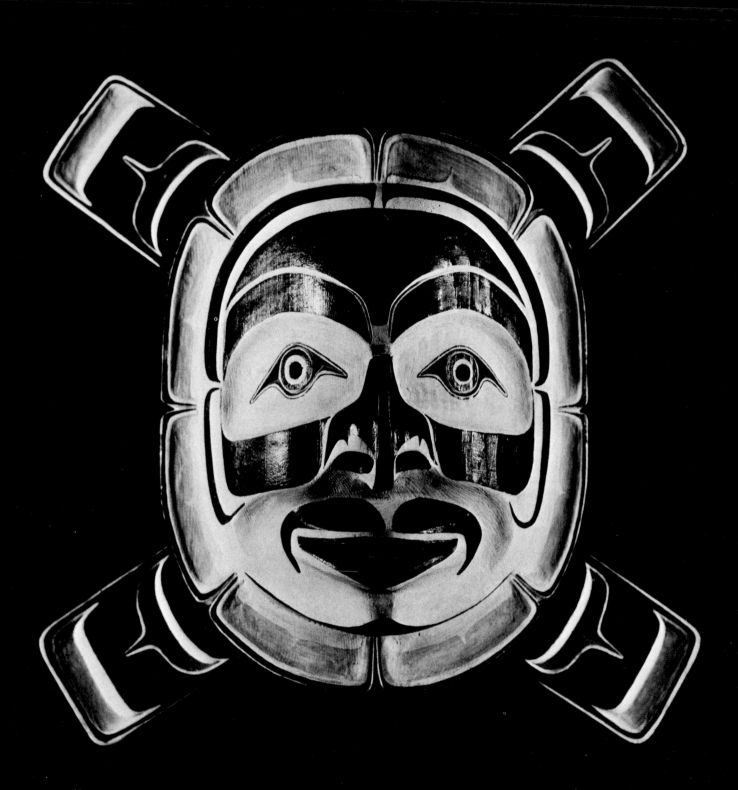

39. Kwakiutl Sun Mask

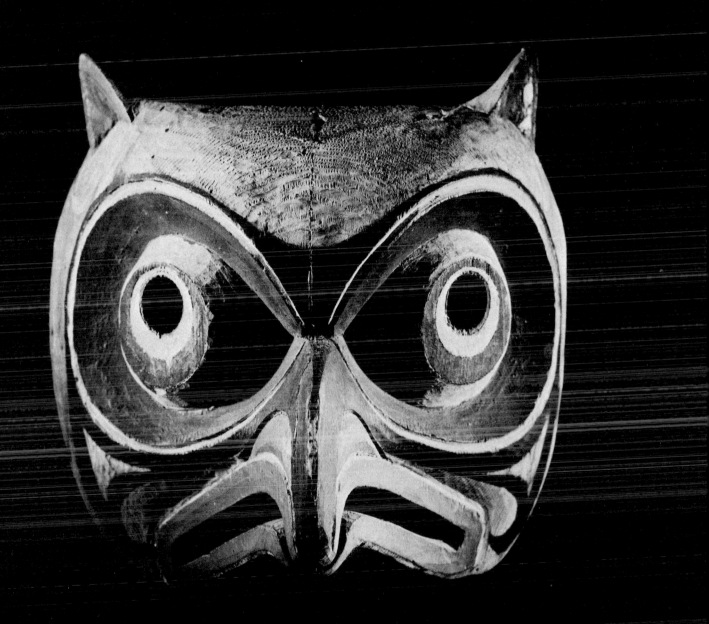

40. Kwakiutl Owl Mask

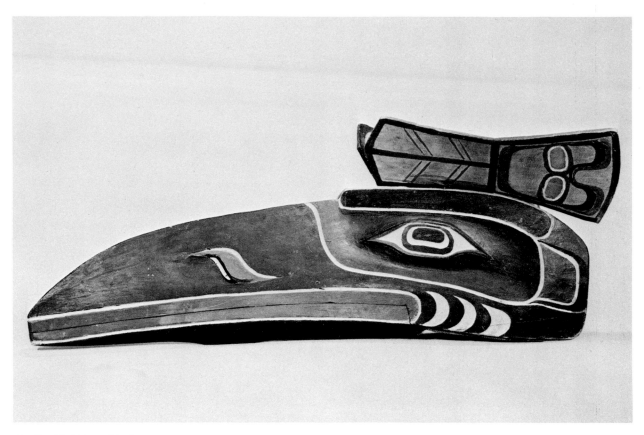

41. Kwakiutl Raven Mask

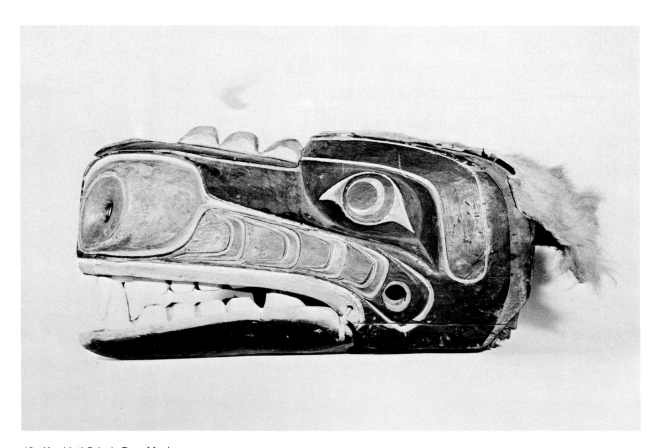

42. Kwakiutl Grizzly Bear Mask

42. **Grizzly Bear Mask.** Wood, fur. L. 20 in. 25.0/211

The dramatic appearance in the house of a dancer costumed as one of the supernatural birds or animals of the family myths is the real climax of the Tlásulá. The grizzly bear, with his flaring nostrils and powerful jaws, is a particularly imposing monster as he hulks into the firelight, swinging his head from side to side, rearing up with raised long-clawed paws, growling and grunting. In the most realistic of these dances the costume consists of a complete suit of bearskin; in others the dancer wears a button blanket over his body. In either version the actions of the dancer simulate the natural movements of the bear, skillfully related to the rhythm of the song and the limitations of the dance floor.

A row of finny protruberances along the snout and the scalelike designs sweeping back from the nostrils suggest that this mask may represent not the ordinary mythical grizzly, but Núnis, the Grizzly Bear of the Sea. If it is Núnis, the costume would probably include a dorsal fin and other sea mammal characteristics as well as the usual attributes of the bear. The mask is very well carved and painted in black, red, green, yellow, and white. Stylistically it is from the 1880–90 period. The jaw is hinged with a simple tie of cord. When it is opened the teeth, which are all attached to the jaw, are exposed.

43. **Thunderbird Mask.** Wood. L. 16 in. 25.0/210

Throughout the masking area of the Northwest Coast, the dramatic effect of opening jaws and other moving parts on masks was recognized and exploited. Of all the tribes using masks, however, the Kwakiutl carried articulation to its highest development. This small thunderbird headdress, another forehead mask, employs two variations on the theme. The lower mandible is hinged to allow it to open and close, and the crest of wooden "feathers" between the thunderbird's ears can be spread like a fan or dropped back to lie flat on the head. Strings control the movement of the parts.

The natural color of the wood has been left as a background. The beak is painted white, and the features are done in the usual black and red.

44. **Killer Whale Mask.** Wood. L. 47 in. 25.0/229

To residents of the Northwest Coast, and particularly to those in the habit of traveling the waterways of the area in small boats, no native creature is more impressive than the killer whale. It is small wonder that Indian mythology and art are full of references to him. Mythical killer whales outdo their natural cousins in size, number and character of fins, and other attributes. This killer whale back mask has the remarkable ability of transforming itself from a single- to a double-finned creature. The forward dorsal fin is solidly mounted in the whale's back. The second fin, concealed in the hollowed back of the forward fin, is mounted on a track that allows it to be slid backward into view. The whale's lower jaw is hinged, and the tail is jointed so that it can be raised over the creature's back. All these movements are controlled from within the mask by means of strings. The flippers were originally hinged but are now lightly nailed to the body so that they move with the action of the mask.

Large back masks representing killer whales, other whales, and sea monsters of various types were often used by the Kwakiutl and can be seen in many collections (Mochon 1966:45-60; Hawthorn 1967:P1. XVII, Fig. 324, and others). They are worn over the dancer's head and back and often have a screen of cloth fastened to the lower edge to conceal his body. The movements are slow and undulating, simulating the action of the whale in the water. The jaw opens and shuts. At intervals in the dance the tail is raised and the other moving parts are operated. The lifelike effect achieved with these rigid wooden parts, mechanically hinged and moved, is startling. The firelight and the dancer's expressive movements help to make the fantastic carving come to life.

In this mask the usual Kwakiutl color scheme of black, red, green, and white is used. The mask was probably made early in this century.

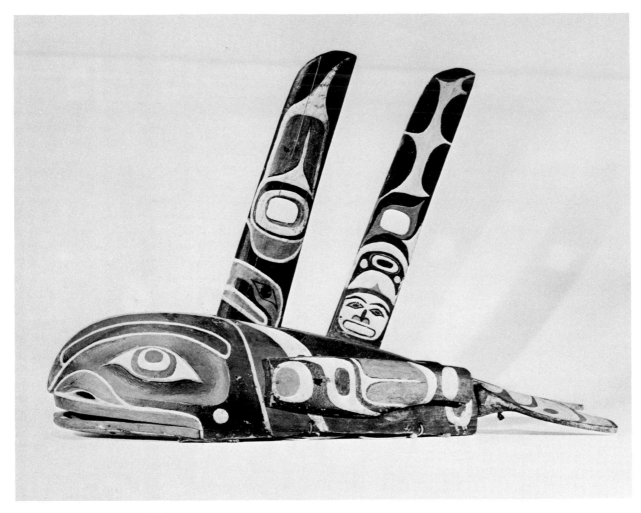

44. Kwakiutl Killer Whale Mask

45. Grizzly Bear Transformation Mask. Wood.
 L. 24 in. 25.0/212

A concept apparently unique to the Northwest Coast and most fully developed by the Kwakiutl is the transformation mask. The creature portrayed in a dance is suddenly transformed into another being, or dramatically altered, by the splitting and opening of a mask to reveal another, or by spreading and moving parts which drastically change the character of the mask. This one is an example of a mask within a mask. The outer form is that of the grizzly bear, made in two hinged pieces which can be opened outward to expose the inner mask, a human face with some bearlike characteristics, especially the broad, upright ears. The whole mask is elaborately painted. The designs on the inner surfaces of the two side pieces apparently represent the bear's profiles in rather abstract form. The traditional colors and color placement are used. Painted on the back of the mask are the words, "Yaklan [a man's name] 1896." This may be the name of a former owner, since it is not likely to be the artist's signature.

Generally, "folding-out masks" (*táhltahlumhl*) of this type illustrate incidents in myths in which the ancestor removes the mask and garments of the animal or bird in which he arrived on earth and, in his human form, founds the family. They may also represent transformation from one being to another, or simply display different successive crests. In use, the dancer enters the house with the mask closed and dances as the represented creature until suddenly, often in coordination with the words of his dance song, he spreads the outer shell. The parts of the outer mask, flanking or radiating out from the inner face, greatly enhance the effect, and the sudden "blossoming" of such a mask never fails to draw gasps of amazement from the audience.

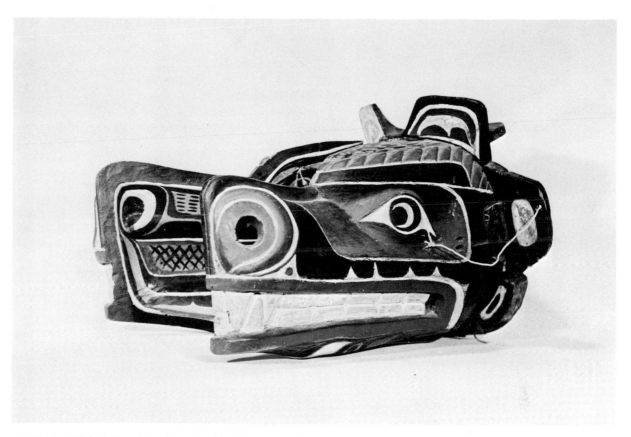

45. Kwakiutl Grizzly Bear Transformation Mask (closed and open)

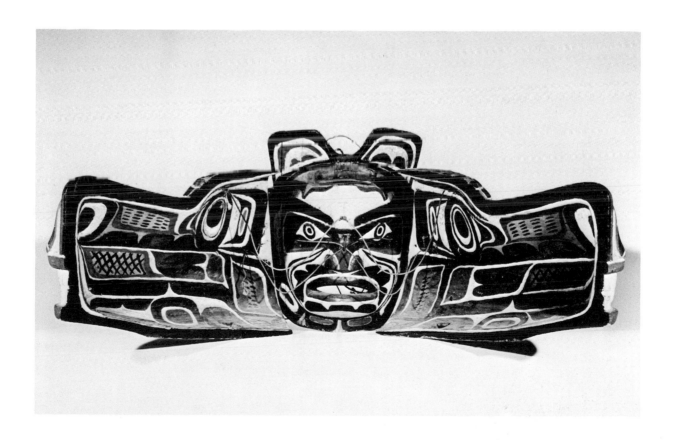

46. Echo Mask. Wood. H. 13½ in. 25.0/221

The echo is conceived as a humanlike being with the ability to imitate the sound or voice of any creature. In the mask this is represented by mouths of many kinds which can be fitted to the mouth of the mask itself. In the song to which the dancer performs, reference is made to the "wonderful mouth" (súms kyáso) of the echo. The extra mouths, of which there may be as many as eight or ten, are carved to fit over the mouth of the mask. A flat plug extends through the mask and is grasped in the teeth of the dancer. The extra mouths are carried in pouches under the dancer's blanket and slipped in and out of the mask under cover of the blanket and the dark shadows thrown by the firelight. There are four mouths with this echo mask: bear, raven, frog, and sea anemone.

The dramatic byplay leading up to the appearance of the echo is unique. Something shouted by one of the attendants after the disappearance of the headdress dancer is "echoed" from behind the screen or from outside the house. The attendants are startled and begin to shout. Every utterance is immediately imitated by the echo voice. The words are shouted through a vibrating wooden mouthpiece so that the sound is distorted. The attendants make comic use of the situation until the echo finally appears at the door and the song begins.

46. Kwakiutl Echo Mask with Four Interchangeable Mouths

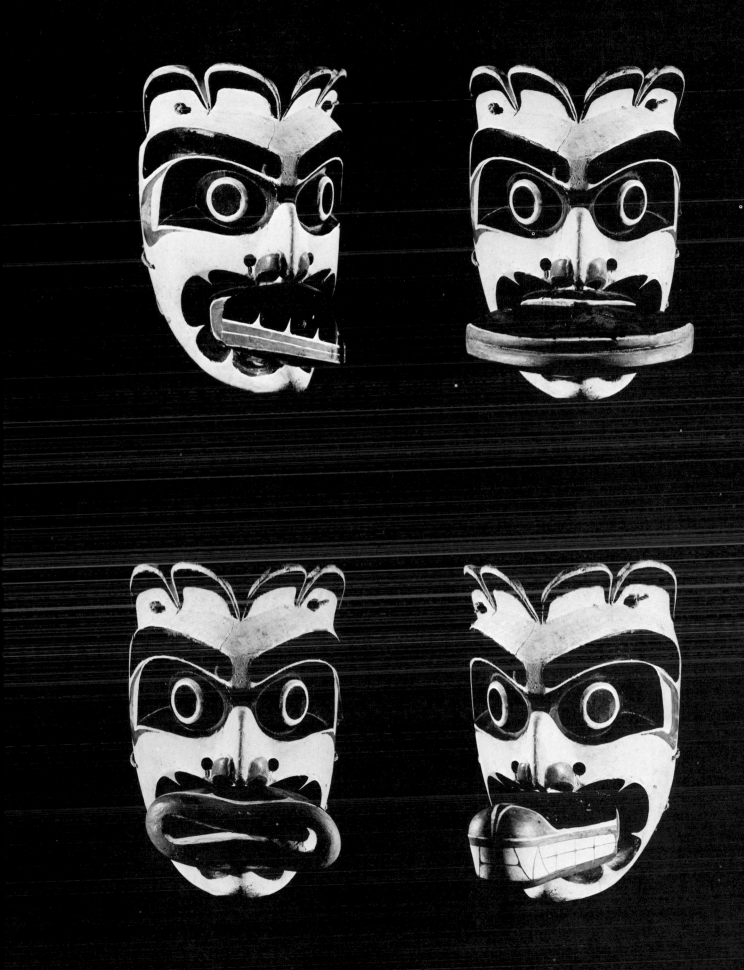

47. Speaking Mouth. Wood. W. 6 in. 25.0/225

Collected from Willie Seaweed and made by him for his wife, who owned the prerogative, this "Calling Down" mouth shows the clean workmanship and design associated with the work of that artist. It is unpainted. The "mouth" was held in the teeth of the owner in much the same manner as the echo mouths are held but without the mask. It was called *héygukhsti* and gave the owner the privilege of publicly "calling down" or critically derogating the people. The remarks were actually made by a speaker who stood beside the mouth wearer. No offense could be taken at his comments.

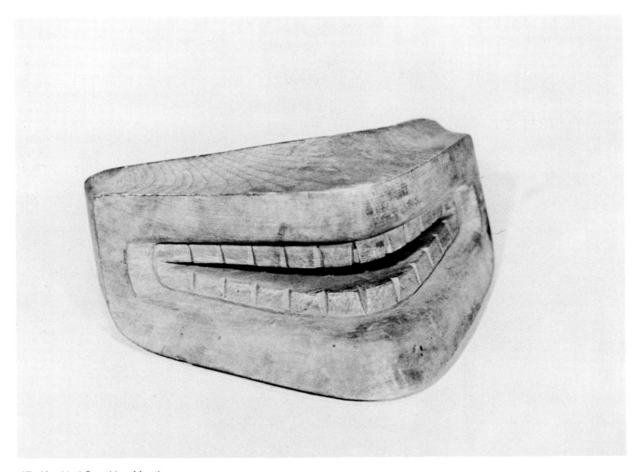

47. Kwakiutl Speaking Mouth

Other Ceremonial Objects

48. **Copper.** Copper. H. 26 in. 25.0/300

One of the most characteristic objects of Northwest Coast Indian manufacture is the unique and enigmatic "copper." Superficially resembling a shield, it had throughout the northern coast a place of high regard as an object of chiefly paraphernalia. Among most of the coastal people, and especially among the Kwakiutl, it was considered to represent monetary wealth. To the Kwakiutl the ownership and display of a copper became an absolute essential for the proper conduct of a marriage or important dance ritual. Coppers often increased in value with each sale until individual examples brought prices running in thousands of dollars. Interestingly, all coppers that have been subjected to metallurgical examination have been found to be of the commercially manufactured metal. A number of studies have been undertaken with a view of determining the origin of the concept and form of the copper, but their results have so far been inconclusive.

Many coppers, like this one, are in a rather shabby, patched condition as a result of having been used in quarrels between chiefs. A man whose family's honor had been assailed, or who felt injured by the actions or remarks of another, would publicly have a piece cut from a valuable copper and give the piece to the offendor. That person was obligated to cut or "break" a copper in return. The broken pieces could be bought up and joined into a new copper or used to replace pieces missing from a "broken" one. Ideally, the original pieces should be rejoined, but if the T shaped central ridge remained the copper could be renewed. The most valuable Kwakiutl coppers tend to be rough and patched, since they have the longest history and have been broken most often. Coppers that have been broken have a certain prestige value that is quite independent of their monetary value. They are proudly displayed by their owners and are frequently represented in art.

This copper has been riveted together of four pieces. It is partially painted black, and a rough design of a face has been scratched in the upper field. Kwakiutl coppers traditionally had names, and the decoration referred to that name. The name or the native value of this copper is not known.

49. Copper. Copper. H. 19½ in. 25.0/301
Another copper, somewhat smaller and in similar rough condition, is also composed of a number of pieces of sheet copper riveted together. On each side of the central ridge, in the lower section, faint diagonal markings are discernible. These are rather common on coppers and are referred to as "ribs." The various areas of the copper are named for parts of the body, and in certain portions of the modern *hámatsa* ritual the copper substitutes for a corpse. A *hámatsa* whose sponsor has no copper to use is sometimes said to have an empty stomach (Duff 1969:335).

50. Copper. Brass. H. 9½ in. 25.0/302
Coppers vary widely in size, but this one seems too small for actual use as a copper. It may have been made for some decorative use. Very small copper-shaped bangles were fastened to the fringes of dance aprons, and some small copper replicas were sewn to the blanket worn by the *hámatsa* in his tame dance. The fact that this one is of brass weighs against its use as a "real" copper. It is more elaborately decorated than either of the larger ones in the collection. A face is painted on the upper, flaring section, and there are stripes and stars on the two sides of the lower part.

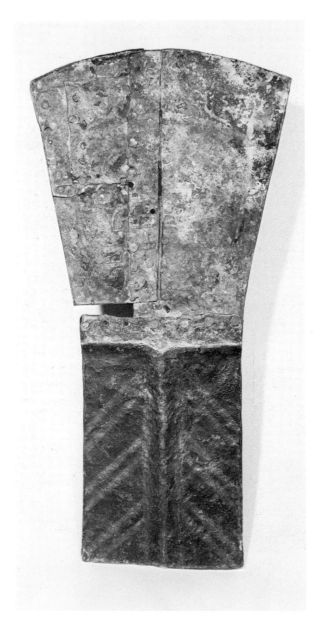

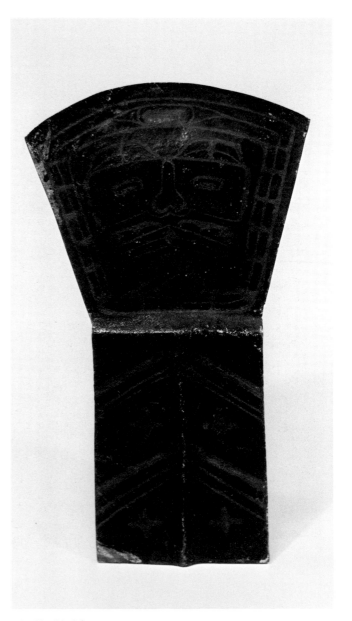

49. Kwakiutl Copper

50. Kwakiutl Copper

51. Button Blanket. Woolen cloth, buttons, beads. W. 69 in. 25.0/274

The copper theme is a favorite one with Kwakiutl artists. Representations of coppers or their T-shaped "backbones" are used as grave monuments, housefront paintings, decorations on masks and carvings (No. 41), and on many other objects. Some of these are commemorative of coppers actually owned, while some must be purely decorative. Button blankets are frequently worked with copper designs, as is this one. The foundation is a green woolen blanket with two broad black stripes. On the upper edge and down the two sides a broad border of red cloth has been sewn, and in typical Kwakiutl style this red band has been decorated with a series of designs worked in buttons and pieces of abalone shell. The figures are abstract floral and geometric shapes and "broken" coppers. In the central field of the blanket is appliquéd a large copper in red cloth, outlined in buttons. Two killer whales in button appliqué and two broken coppers in beadwork further decorate the green area.

The button blanket is the traditional ceremonial blanket of the Kwakiutl. The general form is fairly uniform, with variations in the figures represented and in the details of the border designs. Most have as foundation a dark blue blanket, but green is not uncommon. All the materials in button blankets are products of trade. Even the abalone shell is imported, since the native shells are pale and thin and not ordinarily used for the decoration of ceremonial objects. The thin, slightly irregular, iridescent buttons on this blanket were imported from China and are called Tsúndsus (Chinese) by the Kwakiutl.

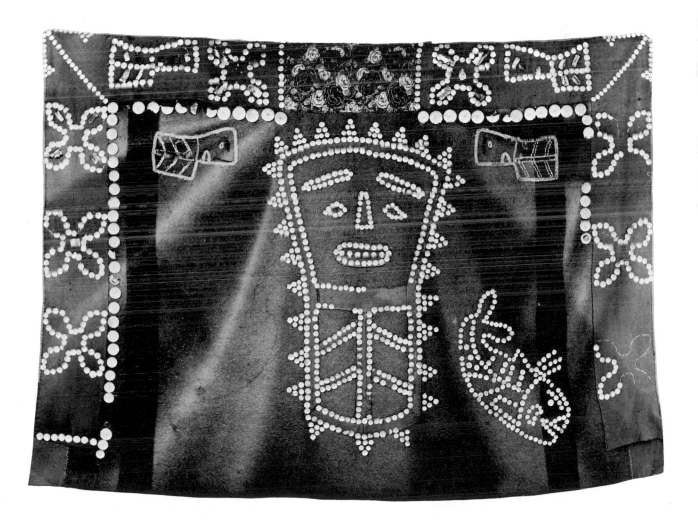

51. Kwakiutl Button Blanket

52. Talking Stick. Wood. L. 62 in. 25.0/234

Many Kwakiutl chiefs had among their ceremonial equipment a carved stick resembling a miniature totem pole, called *yákuntpek* or "talking stick." The chief or his speaker held this stick when making a formal speech. The stick was used for emphasis— pounded against the floor or jabbed into the ground, rested on the shoulder, or held in various positions. Many chiefs today still own and use their talking sticks.

Some sticks, like this one, are simple cylindrical staffs topped with a crest carving. Here the figures are a wooden copper surmounted by a whale's tail. The figures are carved in low relief and painted in green, red, and white. Details of the designs differ on the two sides. The joint of the whale's tail is characteristically developed into a face.

53. Rattle. Copper. L. 7¼ in. 25.0/303

The copper theme is repeated here in a ceremonial rattle in the shape of that esteemed object. The face has been shaped by pounding into a rounded bulge, and a similarly rounded piece of copper has been soldered to the back, forming a cavity that holds a number of small stones, or perhaps lead shot. The characteristic T-shaped ridge appears on the lower section. A series of holes at the lower edge indicate that a handle was once attached at that point.

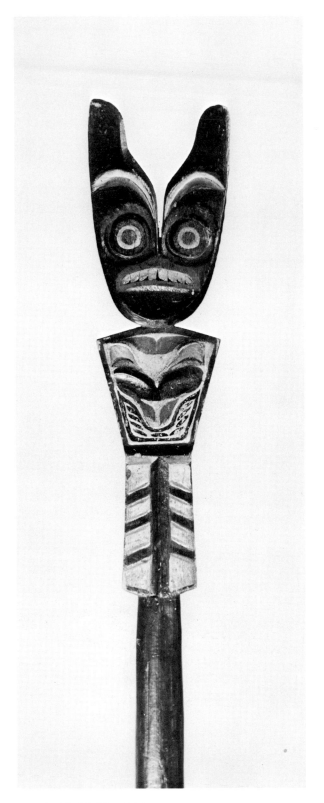

52. Kwakiutl Talking Stick

54. Settee. Wood. L. 56 in. 25.0/257

In times past the Kwakiutl did not use chairs, but habitually sat on the floor or on the ground, sometimes leaning on the platform of the house, or on a plank fastened against stakes driven in the ground. A wealthy chief might have a more elaborate settee, carved and painted with his crests. This small settee, consisting of a rectangular back and hinged, sloping sides, was probably made for a favored child. The design carved and painted on thin hand-made boards is of the Sísioohl and is the work of the Kwakiutl master, Willie Seaweed. The Sísioohl is a mythical creature usually represented in the form of a serpent with a face in the middle of his body. At each end was a head with a curled horn and nostril and a long, sharp tongue. It was a dangerous creature, capable of bringing harm or death to anyone coming upon it. At the same time, for the person who was properly prepared to deal with the Sísioohl, the acquisition of its scales, spines, or blood could bring great power. It is the frequent subject of stories and art.

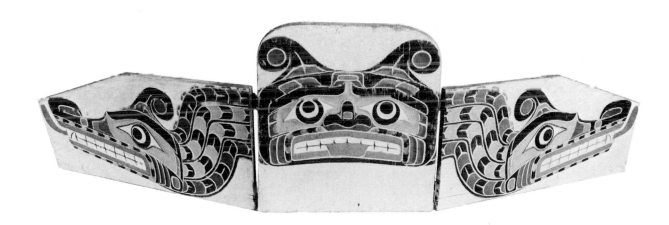

54. Kwakiutl Settee

55. **Cradle.** Wood. L. 34 in. 25.0/243

Another example of the work of Willie Seaweed in
the Gerber Collection is a decorated cradle. It is in
the traditional Kwakiutl cradle form, a narrow open
box with a high headboard at one end, but it has
been fitted with a pair of transverse rockers. These
were not used on ancient cradles, which were often
hung from springy poles so that they could be
"rocked" by rhythmic tugs on a cord.

Decorated cradles like this one were used only
by nobility, and the designs were probably valued
family crests. This design represents a whale on the
long sides and a copper on the back of the
headboard. The whole surface is carved in low
relief and painted in black, orange, yellow, red,
white, and green on a blue ground. It was collected
at Blunden Harbour, the home village of the artist.

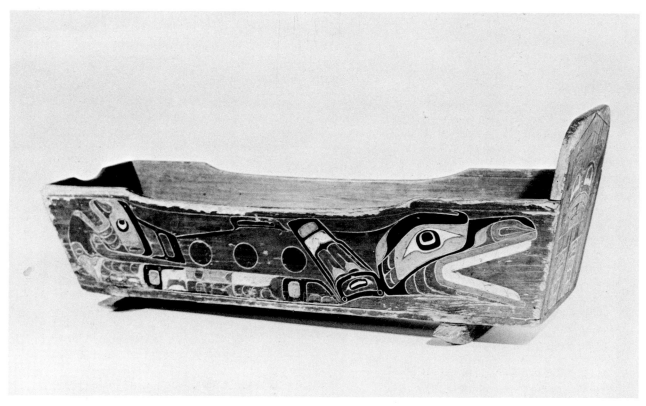

55. Kwakiutl Cradle

Dishes and Ladles

56. Bowl. Wood. L. 18¾ in. 25.0/292

Wooden dishes came in a great variety of sizes and forms. Many were essentially undecorated and can be thought of as wholly functional, although they frequently have an elegance of proportion and form that raises them above their utilitarian role. This plain bowl is of this sort. It was used for serving ordinary food and is not in any way a ceremonial piece.

57. Ladle. Wood. L. 13½ in. 25.0/247

Simple, undecorated wooden ladles, beautifully proportioned, shared everyday duty with plain dishes and bowls. This ladle, decorated only with a shallow groove paralleling the inner rim (a conventional ladle feature throughout much of the northern coast) again depends for its effect on the satisfying proportions of its broad bowl and short curved handle. The wood, probably alder, has been stained almost black by an infusion of the candlefish oil which it once held in use.

58. Wolf Feast Dish. Wood. L. 86 in. 25.0/242

In contrast to the modest size and simple form of the bowl described above, this great dish exemplifies the extravagance and ostentation of Kwakiutl ceremonial utensils. A typical feast dish, it is conceived as a large sculptured animal hollowed to receive the food it is to serve. In this case it represents the wolf. Dishes of this sort were part and parcel with the house of the owner (hence the native term *hloókwihl*, "house dish") and were accounted for in the origin myths of the family. They were very highly valued and were used only on the occasion of great feasts. Filled with food, they were brought out and their history and mythical origin were recounted. Then their contents were distributed. Samuel Barrett recorded a very detailed description of the use and etiquette surrounding the use of a large Dzoónokwa feast dish (Mochon 1966:88–91).

This dish is probably quite old. It is much weathered, and the ears and part of the tail are missing. Traces of black paint on the eyebrows and snout and green paint in the nostrils and eyesockets remain. The body of the wolf retains the very regular decorative adze marks which are characteristic of many large carvings of the Kwakiutl. The carvers frequently make good use of this final surface adzing to add interest and variety to large, otherwise plain areas.

59. Man Feast Dish. Wood. L. 76 in. 25.0/241

This dish is carved in the form of a reclining human figure, knees drawn close to the body, head extending outward at the opposite end, and hands grasping the rim of the bowl, which encompasses the whole torso. The carving of the disk-shaped head is highly stylized in the Kwakiutl manner and is painted in black, yellow, green, and white. A carved rim resembling rope surrounds the face. It probably represents the twisted red cedar bark that has such a prominent place in the Tséyka ritual. The effect of the carved fingers grasping the rim of the bowl is that of the man spreading open his body to receive the food, a concept seen in other dishes from this and other parts of the coast.

60. Carved Face Plaque. Wood. L. 16 in. 25.0/224

Almost identical in form, color, and size to the head of the preceding man feast dish, this carving may have been salvaged from a matching dish. It certainly is related in some way. The lower surfaces of old dishes are often rotted and riddled by insects as a result of the custom of storing them on the ground under the houses, which, in the years since the abandonment of the traditional native house, have been frame houses raised on short pilings. The head may have been cut from an old dish that had lost its function through the rotting of the bottom.

61. Sísioohl Ladle. Wood. L. 47½ in. 25.0/258

Great ladles, with figures of mythical creatures carved on their handles, are used to distribute food from the feast dishes. The Gerber Collection includes a fine pair of large, old ladles decorated with carved Sísioohl heads. The form of the ladle is exactly that of the ordinary small wooden spoon of the Kwakiutl, enormously enlarged. The Sísioohl head is conceived as an extension of the handle, bent back upon itself and joined to the neck of the spoon. The head, with its coiled nostril, scaly crest, and spiral horn, is deeply carved and painted in black, red, green, and white. The painting is carried down the neck of the ladle to represent the highly conventionalized body of the creature.

62. Sísioohl Ladle. Wood. L. 46 in. 25.0/259

The second ladle of the pair differs from its mate only in details of painting and in the addition of a small copper nailed to the nose and curling up over it like a tongue. Stylistically these two pieces belong to the late nineteenth century. They were made as a pair and were later separated in transfers related to several marriages. The Gerbers purchased them from two different families, permanently reuniting the pair.

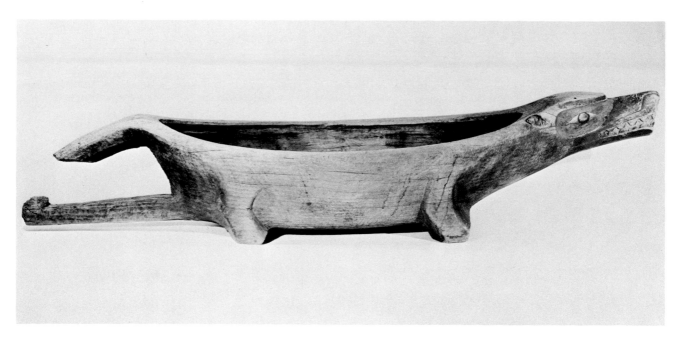

58. Kwakiutl Wolf Feast Dish

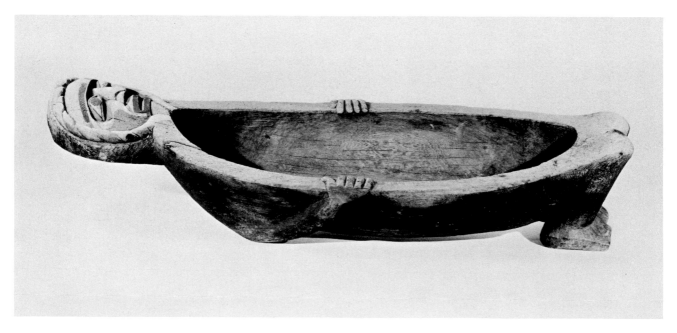

59. Kwakiutl Man Feast Dish

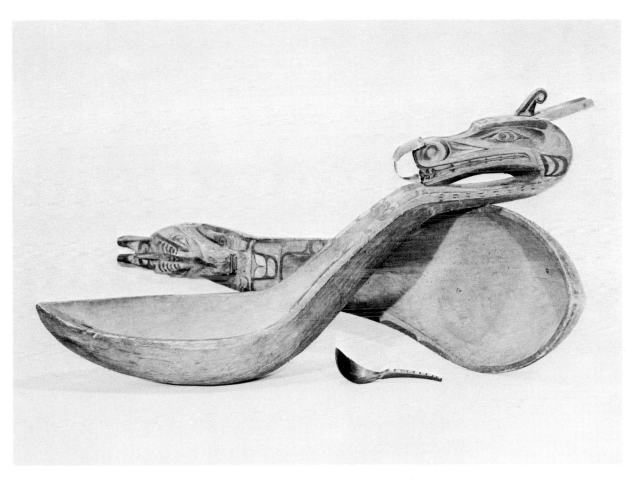

61,62. Two Kwakiutl Sisioohl Ladles (spoon indicates scale)

Carved Figures

63. **Eagle.** Wood. H. 35 in. 25.0/272

The Kwakiutl are known as a totem pole people. The tall, carved columns that decorate their villages scattered along the inside passage at the north end of Vancouver Island have been admired by travelers to and from Alaska and northern British Columbia for years. A pair of Alert Bay house posts, still standing, have been the models for the vast majority of souvenir totem poles carved as far away as Japan, and their subjects, thunderbird and grizzly bear, are perhaps the best known of all totem pole themes. Tall, completely sculptured poles were, however, almost entirely a development of the turn of the century. Before that time most Kwakiutl totemic monuments were either interior house posts or single figures of birds, animals, and mythical beings perched on the house gables or on tall, plain masts.

This carving of an eagle is of the latter kind. The outspread wings are separate attached pieces, as is characteristic of many large Kwakiutl sculptured figures. Kwakiutl carvers are less bound by the limits of the wood they use than are their northern counterparts, and they freely pierce, shape, and alter the cylindrical form of the cedar logs they work with. The eagle has painted feathers that are highly stylized in a way closely resembling the northern system of two-dimensional decoration. From the character of this painting—in black, red, green, and yellow on a white background—and of the sculptural form, the piece can be attributed to Arthur Shaughnessy. A prominent carver and the contemporary of Mungo Martin, Willie Seaweed, and other important artists, Shaughnessy carved tall totem poles and house posts as well as small figures and souvenir totem poles. The magnificent house posts from Chief John Scow's Raven House at Gilford Island, now restored in the Pacific Science Center in Seattle, are also his work.

64. **Eagle Totem Pole Fragment.** Wood. H. 33 in. 25.0/273

This figure stood on top of a pole that was erected in 1928 at the time the Fort Rupert Kwakiutl were called to a great potlatch at Blunden Harbour. The eagle was carved by Willie Seaweed, the chief of the Nákwakdakw, and was said to be watching for the arriving tribe. Even in its fragmentary form the strength of design and execution characteristic of the artist is apparent. It is carved of red cedar and painted in black, red, yellow, and white. Much of the paint has weathered away, but enough remains to suggest its original appearance.

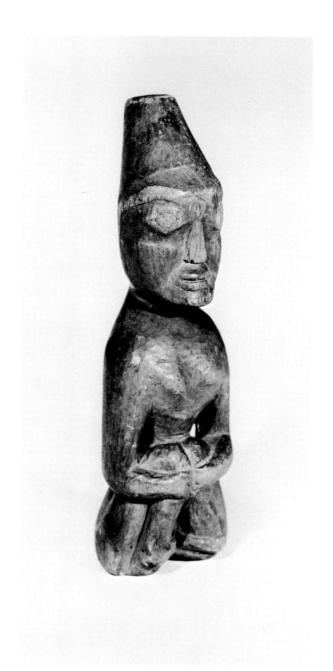

65. Kwakiutl Carved Seated Female Figure

65. **Seated Female Figure.** Wood. H. 10½ in. 25.0/308

The function of small carvings of human figures like this one is unknown. There are many of them in collections, and some at least were carved for sale to white men. Here a seated female figure is represented. She sits with knees drawn up in the characteristic posture of the old-time Kwakiutl women. The pose is at once typically Indian and well suited to carving. The lady's head is elongated in the form of a truncated cone which may represent a basketry hat, but more likely here depicts the type of skull deformation prevalent among Kwakiutl women at the time of European contact. The carving is direct and bold. There is no trace of painting, but the piece has a rich brown patina.

66. **Mask Figure.** Wood. H. 10½ in. 25.0/240

The function of this small figure is not certain, but the tenon at its base and its resemblance to other figures suggest it was probably attached to the top of a mask. Some of these are jointed and can be made to move and gesture. The little man, rather roughly carved, sits with upraised arms, one of which is a recent and less well-modeled replacement. The entire figure except this arm is painted white with detail in black and red.

67. **Hand Puppet.** Wood, cloth, and buttons. H. 12 in. 25.0/245

Movable figures ranging in size from great house posts with snapping beaks to tiny creatures held and displayed by conjurers were constructed by the inventive Kwakiutl artists. The best known are the various figures used to demonstrate the supernatural power of the Toógwid dancer of the Tséyka series. These may be birds that descend from the smoke hole and fly around the house, creatures that crawl around the floor, or inanimate objects that come to life. The mechanical skills of the makers were called into full play, and solutions to the problems of animation were often simple and ingenious.

Although this small hand puppet was made for sale in recent years, it is clearly in the line of the tradition of Kwakiutl movable figures. It is the work of the late Ellen Neal, the granddaughter of Charlie James who was one of the best known Kwakiutl carvers and an important figure in the development of the Kwakiutl style of art as we know it in this century. Charlie James was Mungo Martin's stepfather and teacher. The puppet's head and headdress are carved of wood and carefully painted in the traditional colors, and the body is made of blue cloth appliquéd with red cloth and buttons to suggest a dancing blanket. The design of a copper is worked on the back.

68. **Miniature Mask.** Wood. H. 4¾ in. 25.0/321

This small mask, probably representing the Dzoónokwa, is of a sort made for sale to tourists and collectors. Small masklike ornaments were made for ceremonial use and attached to masks, neck rings, and headdresses, but they are usually of better quality and exhibit signs of use or have holes for ties drilled in the edges.

69. **Miniature Mask.** Wood. H. 4 in. 25.0/325

Bugwís, the Merman, is represented in this miniature mask, an example of the small carvings made in great numbers today by the Kwakiutl for sale in souvenir outlets. These carvings are usually very simple, often roughly carved and finished stained a dark gray-brown, rather than being painted in the traditional way. The stained finish is in response to demand by dealers, who claim that tourists prefer carvings with this color for decorations. Sculpturally this mask is a much simplified version of a style of modeling evolved from traditional Kwakiutl sculpture by the carvers working in Victoria for the Provincial Museum.

The mask can be identified as Bugwís by its large rodentlike incisors and the browline merging in a downward sweep with the nose.

70. **Miniature Mask.** Wood. 4⅛ in. 25.0/326

This small mask depicts a man wearing a cedar bark headring. He may represent Tséykami, a mythical man usually shown with the cedar bark ornaments of the Tséyka. Like the previous mask, it is representative of the low-cost souvenir carvings available in many shops.

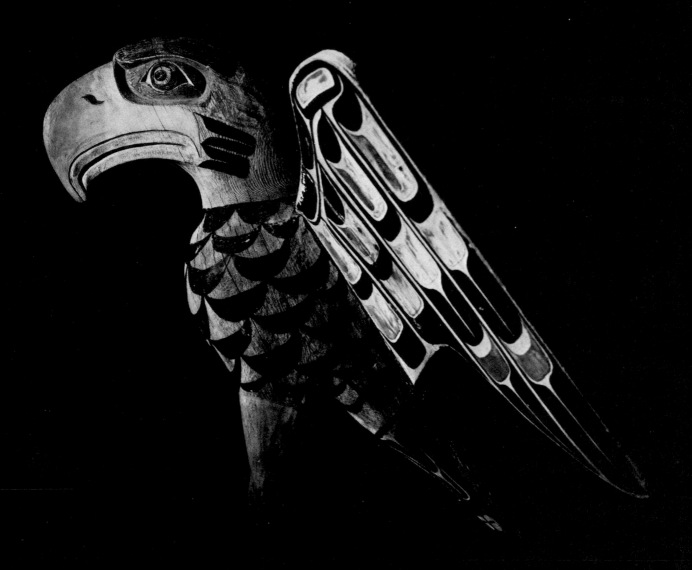

63. Kwakiutl Eagle

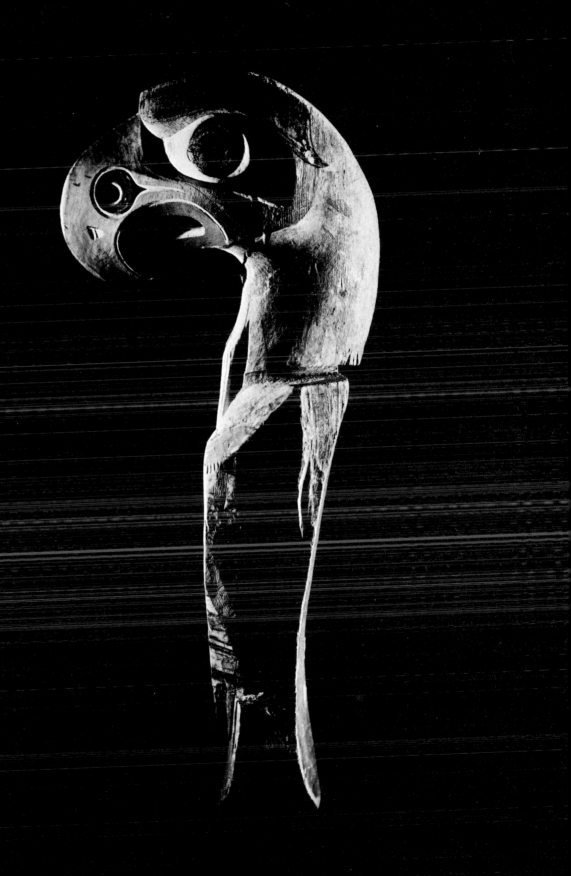

64. Kwakiutl Eagle Totem Pole Fragment

Nootka

The Nootka-speaking people of the West Coast of Vancouver Island share many culture features with their northern neighbors, the Kwakiutl. Both depended on the sea and the forest for their livelihood, mask dances form a major part of the ritual practices of both groups, they speak related but not mutually intelligible languages, and their concepts of rank and privilege are similar.

The arts of the Nootka and the Kwakiutl are derived from these similar backgrounds, cultural and environmental. Both groups developed the carving and painting of wood as major art forms. It is significant that at the point of demarcation between Nootka and Kwakiutl lands we can discern the line of a major change in art style, the two branches of which extend north and south to the limits of the Northwest Coast culture area. It may be that this change actually marks the limit of a southward-spreading system of art conventions, highly organized and sophisticated, over what might have been a much older and more universally distributed direct, ingenuous, representational style. The influence of the Northern Graphic style was being felt by the Nootka artists of the late nineteenth century, but before that influence had really asserted itself, the strength of the northern art ebbed.

Nootka sculpture can be described as being somewhat less consciously composed in terms of space division and form than most northern sculpture. Flat surface decoration tends to be more geometric in structure, more openly decorative, and—even in the case of those Nootka works which show northern influence—more individualistic.

71. Face Mask. Wood. H. 14¼ in. 25.0/312
This face mask, representing a man wearing what appears to be a ceremonial head ring, illustrates characteristics of sculpture in the planes of the face which are clearly in Nootka style. The depth of the mask from front to back is on the average greater than in a Kwakiutl face mask of similar type, and the basic structure seems to be organized on two planes intersecting on the median of the face. The features are particularly distinctive, the most uniformly structured area being the brow-eyesocket-cheek complex. All the northern tribes down to the Kwakiutl construct the eye on a bulge, more or less pronounced, the lower edge of which intersects a plane sloping inward from the area of the cheekbone. In some masks this structure is very subtle, while in certain Kwakiutl and Bella Coola examples it is bold and sharply defined. Nootka masks, such as this one, slope more or less sharply back under the brow to intersect the plane of the cheek, upon which the eye is defined by painting or flat relief carving. The nose, usually long and narrow, stands out sharply between the eyes. This concept, with the eyes set on the plane of the cheek under a protruding brow and flanking a narrow nose, continues down the coast to the Columbia River. Salish and Chinook sculpture differs from Nootka work in other ways, but all three share this concept.

The mask has been left the natural color of the wood except for a black band on the head ring, black eyebrows, and narrow black lines defining the eyes.

72. Face Mask. Wood, fiber. H. 14 in. 25.0/217
Typically Nootkan in the kind of structure just described, this mask has features that suggest a conjectural identification as a sea creature on the order of the Kwakiutl Bugwís. The mask is painted dark red, with the features in black and white. A fringe of grasslike material is attached across the top of the mask and falls behind, simulating hair. This is a well-finished and strongly designed mask from Queen's Cove on Esperanza Inlet, north of Nootka Sound.

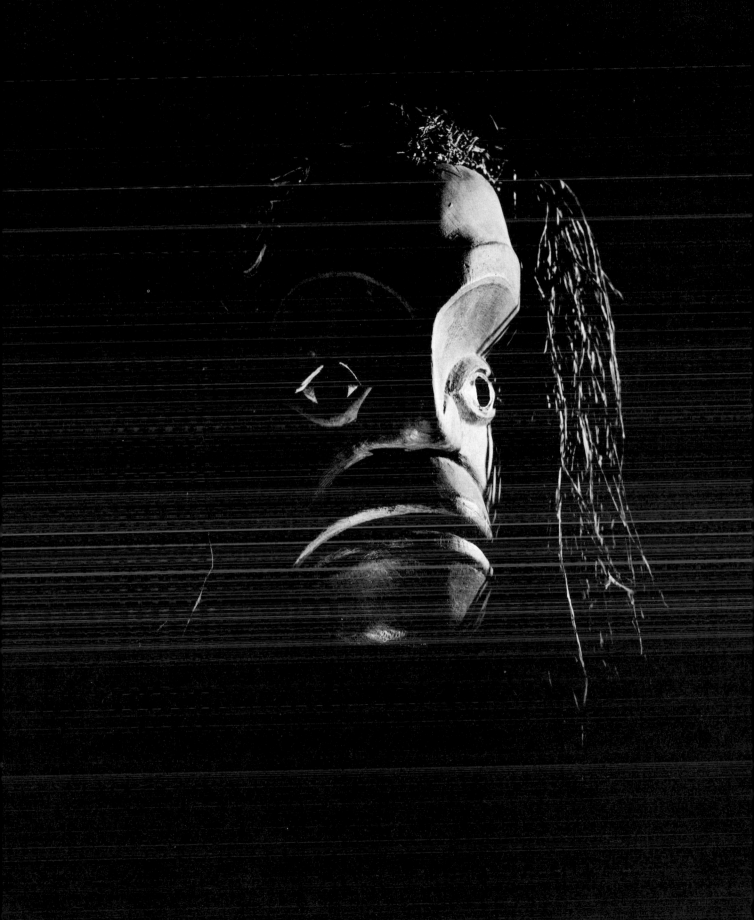

72. Nootka Face Mask (profile view on following page)

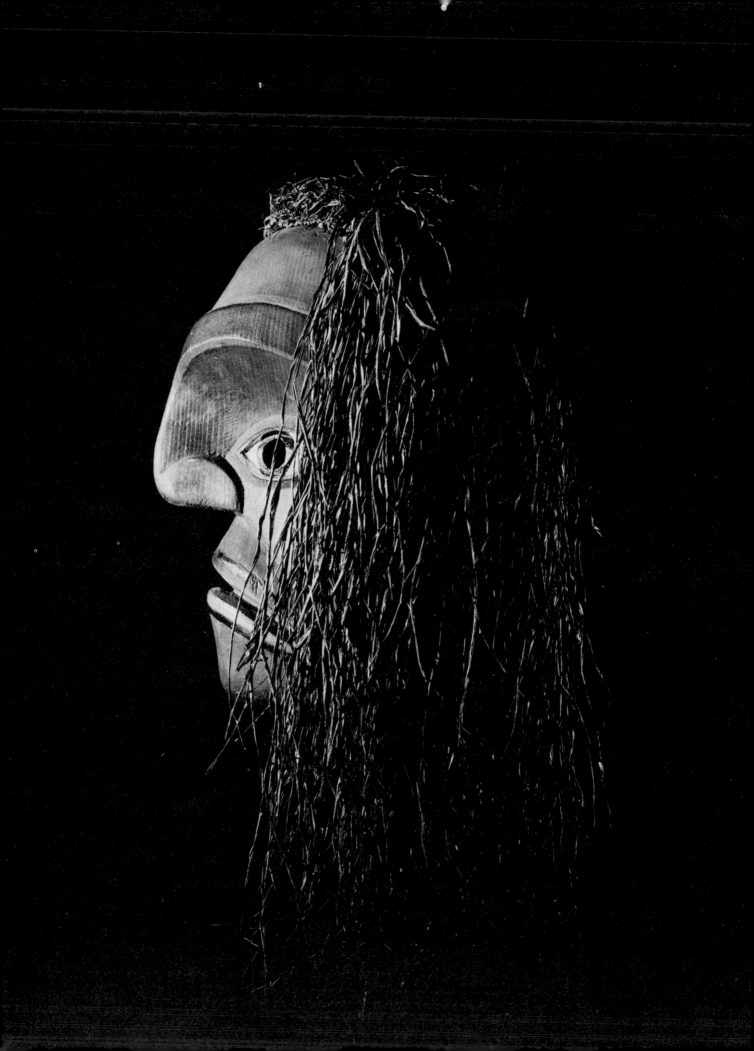

73. Raven Mask. Wood, feathers. L. 16½ in.
25.0/216

In the course of the great Nootka winter ceremonial, Kloókwana (which roughly corresponds to the Kwakiutl Tséyka) masks of certain birds and animals are worn. One of these is the raven mask, and it is likely that this one was so used. Almost identical with a mask in the collection of the University of British Columbia Museum of Anthropology (Hawthorn 1966: Fig. 387), it very likely originated in the same village of Ahousat on Clayoquot Sound. The mask is very simple in form, with an articulated jaw and a crest of bald eagle feathers attached to the top of the head. The entire surface is painted black, except for the eyesockets and the inner surfaces of the lips, which are red. Small rounded ears protrude from the crown. Two pairs of cloth ties are fastened to the lower edge. These are tied around the neck and under the chin of the dancer. The mask sits on the head, leaving the dancer's face exposed, but in the shadows of the firelit dance house, the strong silhouette of the raven's beak and the spreading blanket "wings" carry the impression of the great bird with remarkable realism.

73. Nootka Raven Mask

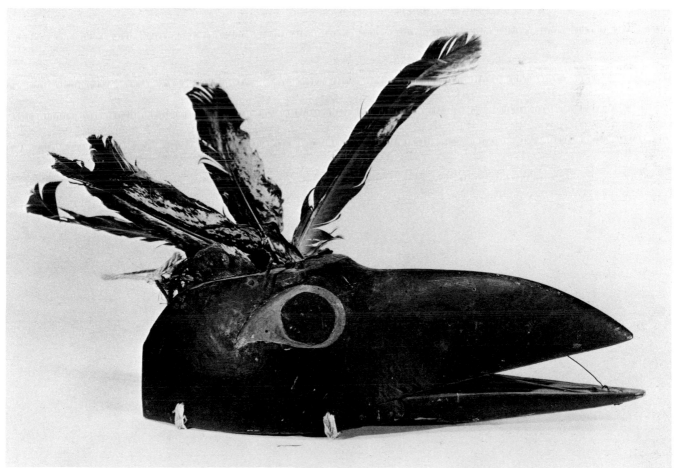

74. Carved Staff. Wood. L. 50 in. 25.0/235

On the basis of the form of the carved figures and the painted designs, this staff can be identified as Nootka work. It is made of very heavy wood, nicely finished. The structure of the large face at the upper end is similar to that described for the preceding Nootka face masks, and the freely handled painting is typical West Coast use of northern design elements. The figure of a sea otter is carved on the back of the head and painted black. Blue, black, red, and white are used in the painted designs. It was probably used as a talking stick.

75. Hand Adze. Wood, steel. L. 10½ in. 25.0/271

This D-adze, a basic Northwest Coast woodworking tool, is one of a number of pieces acquired by the Gerbers from various dealers and without specific identification. On the basis of its form and the style of its decoration, however, it can with considerable assurance be called Nootka. The particular style of adze is practically confined to Vancouver Island and the adjacent Washington coast, and of the tribes using it only the Nootkan speakers habitually decorated the handles in this way. Further to the north along the coast the long-handled elbow adze was the carver's choice, while to the south variations on the D-adze, a short-handled elbow adze, and the straight adze were found. The Kwakiutl had the best of both worlds, using the D and elbow types interchangeably. Adzes are in wide use by Indian carvers today. The great efficiency of the steel-bladed adze for shaping wood is well recognized by the contemporary carvers as it was by their ancestors, who eagerly traded for steel bits with the seamen who visited their coast. The treasured steel was worked into replicas of ancient stone and bone blades, even as it is today.

The long steel blade of this adze, forged from a heavy bar, is attached to the hardwood handle with screws. The upper end of the handle is carved to represent the head of an animal, apparently a bear, with a large Nootka-style eye, crosshatched nostril, and massive, exposed teeth. The eyesockets and teeth are painted red. A smooth polish on the grip attests to its longtime use.

74. Nootka Carved Staff

Other Tribes

76. Bear Mask. Bella Coola. Wood.
H. 11½ in. 25.0/213

Bella Coola carvers rivaled those of the Kwakiutl in producing spectacular masks, many with moving parts. The Bella Coola were Salish migrants to the coast who assimilated a great deal of the culture of the tribes with which they became neighbors, but brought with them an elaborate cosmology very different from the concepts of the coastal tribes. A multitude of supernatural beings in the Bella Coola concept of the universe furnished almost limitless inspiration to the artists, who also developed a unique art style of great strength and beauty. Typically their sculpture is bold, built of strongly curved and intersecting planes, and elaborated with broad painting on the natural wood in black, red (typically vermilion), and a rich cobalt hue which is so much a part of their art that it has sometimes been called "Bella Coola blue." This face mask of a bear illustrates all these characteristics. The carving and painting are strong and direct. The ears are carved in one piece with the mask, and the jaw is hinged to the mask with wooden pins through the cheeks. It was probably made before the turn of the century.

76. Bella Coola Bear Mask

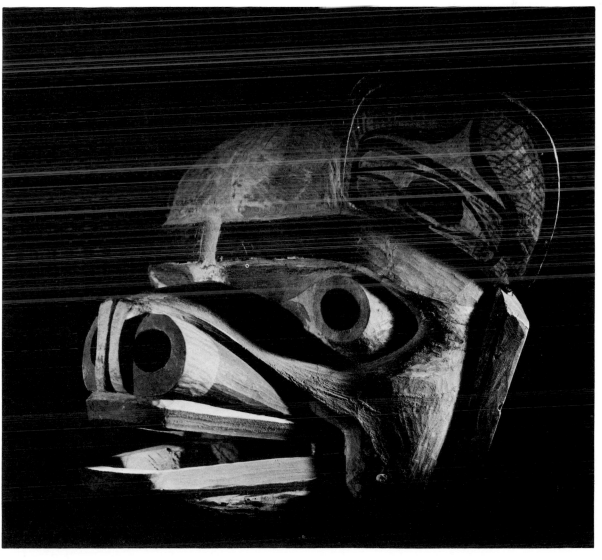

77. **Dance Kilt.** Tsimshian. Cloth, ribbons, skin, thimbles, hoofs. W. 64 in. 25.0/304

Kilts and aprons were worn by dancers and shamans all along the coast. The form of the apron and the style of decoration varied from place to place. This typically Tsimshian piece is a very good example of the adaptation of new materials to old concepts. The ancient dressed skin kilt had this same form and was hung with fringes tipped with deer hoofs or puffin bills. Many skin kilts were painted in the classic northern style, but some of the upriver Tsimshian customarily decorated theirs with bands of porcupine quillwork. More modern kilts, like this example, were of woolen cloth trimmed with appliquéd bands of contrasting material. Deer and caribou hoofs continued in use, and puffin bills when available, but a new bangle, the brass and later the aluminum thimble, was added.

The kilt is wrapped around the waist and tied in place, the lower fringe reaching below the knees. In full dress the performer wears similarly made leggings below the knee, a button blanket or Chilkat blanket over the shoulders, and the appropriate mask or headdress. The apron is a rich visual and auditory part of the whole ensemble.

78. **Rattle.** Tsimshian. Wood. L. 12¼ in. 25.0/293

The oval rattle and the dance kilt are often associated in use as part of the shaman's regalia. This Tsimshian rattle, of hard maple, is typically undecorated. Several elements of its design combine to make it esthetically satisfying. The very smooth globular shape, with a subtle tendency toward angularity; the narrow flaring rim at the joint of the two shells; and the swelling at the distal end of the slim grip lend elegance to the simple instrument. It has taken on a rich amber patina through use. The two halves are joined at the handle with wooden pins and at the sides with ties of skin thongs.

79. **Crane Head.** Mountain sheep horn, abalone shell. L. 4½ in. 25.0/255

This delicate northern carving in translucent horn is of unknown use. It may have been riveted to a horn spoon bowl to serve as a handle. The place of its origin is also uncertain, but the combination of material, concept, and handling of detail resembles Tlingit work. The gracefully arched neck and long, delicately carved head with half-open beak attest to the sensitivity of the Indian artist. An inlaid eye of iridescent blue abalone shell gleams from each side of the head. Narrow crescent nostrils complete the design.

80. **Totemic Carving.** Tlingit. Wood. L. 5 in. 25.0/250

This carving in hard, dark wood, resembling a tiny totem pole, is another piece of unknown use. A short, pointed tenon on the lower end must have been the means of attachment to another part. It is unlikely that this is actually a miniature totem pole. The figures represented are a bear, much elongated, with a small eagle held against its chest. The amount of detail included in this miniature carving is exactly equivalent to that seen on similar carved figures of colossal size. Details of eyes and nostrils, the claws of the bear and eagle, the bird's ribs, and the stylized structure of his wings are all delineated in the classic northern style. This irrelevance of scale to size has often been noted in Northwest Coast art.

81. **Ear Pendants.** Abalone shell. L. 1½ in. 25.0/254 a,b

Abalone shell imported from California and the Pacific islands was an important material for the Indian artist. Shells with deep blue and green coloration were prized. The material was often used for inlays, but plaques and shaped pieces were also used as ornaments in themselves. This pair of earrings are shaped of abalone shell to resemble the large shark teeth which were prized as earrings. The shark teeth were also imitated in ivory, bone, copper, silver, and gold. Especially large fossil examples were identified as the teeth of various sea monsters and had the status of family treasures.

82. **Labret.** Wood. L. 3½ in. 25.0/251

The custom among northern noble women of wearing a labret in the pierced lower lip excited the curiosity and the disgust of early European visitors to the coast. The natives, in their turn, were equally appalled at the "barbaric" ways of the white seamen. In the long run, under the influence of Western "civilization," the use of the labret died out, but examples of the ornament remain. The labret in the Gerber Collection is of carved wood, bearing the figure of a whale in low relief on one face and abstract design elements on the other. A shallow groove runs around the sides to secure the labret in place in the pierced lip.

78. Tsimshian Rattle

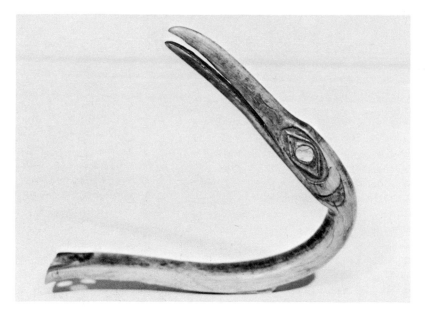

79. Crane Head

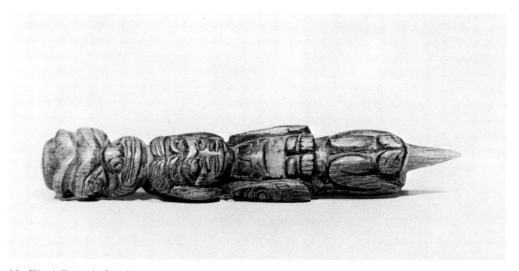

80. Tlingit Totemic Carving

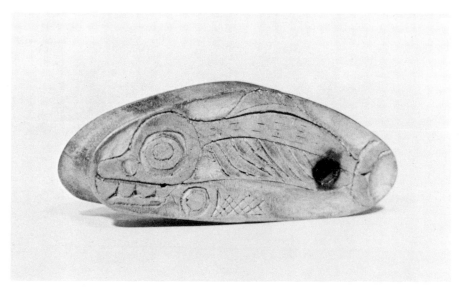

82. Labret

83. Amulet. Bone. L. 5 in. 25.0/256

Amulets and charms of many materials were used by the shamans of the northern tribes in curing sickness. Some of them were attached to the doctor's costume or hung in his neck ring of bone pendants. The subjects of the carvings on these charms were personal to the shaman, revealed to him in trances or in some way related to his supernatural helpers. The octopus, as seen in this bone charm, was a common theme. A bear and a human figure are also represented, and the whole carving has been rubbed with red pigment which remains in the recesses and accentuates the modeling of the figures. The piece is probably late nineteenth-century Tlingit.

84. Amulet. Bone. H. 2 in. 25.0/253

This small amulet, beautifully carved of granular bone with a rich brown patina, is probably Tlingit, from the early nineteenth century or before, judging from the style of work. The figure resembles a bear's head with a fish with a continuous dorsal fin gracefully arched over the top. The carving is at once delicate and strong. The piece is a fine early example of the close relationship between the two-dimensional formline system of decoration and sculpture in the northern coastal area. A small hole for suspension or attachment has been drilled through at the corner of the "bear's" mouth.

85. Amulet. Stone. L. 2¼ in. 25.0/252

Another tiny amulet in the Gerber Collection is carved of a gray-brown stone. Of an irregular I shape, it depicts a number of figures including frogs and land otters, both animals frequently seen represented on shamans' paraphernalia and considered to be related in some way to the spirit world. A hole drilled through the center appears to have been used for suspension.

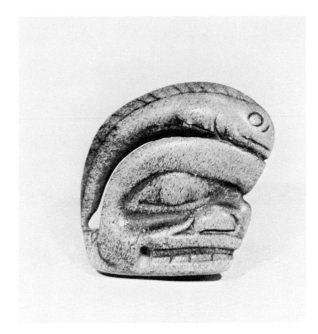

84. Amulet

83. Amulet

86. **Carved Figure.** Tlingit. Wood.
H. 5½ in. 25.0/249

Small figures like this one, sometimes dressed in a miniature replica of the shaman's regalia, may have been made for use in his practice. They somewhat resemble Haida argillite shaman figures, which were carved for sale. This small man half-crouches, his hands on his knees and his mouth open as if he were speaking or singing. A projecting flange on top of his head appears to have been a means of attaching hair or a headdress. His relatively large and boldly modeled face is painted deep blue with black eyebrows and eyes and red nostrils and lips. His entire body is red.

87. **Pipe.** Sandstone. L. 1½ in. 25.0/344

Pipes were made and used on the Northwest Coast from the period of white contact when the custom of smoking tobacco was introduced. They were made of many materials and in many forms. Some were in imitation of the pipes brought by the seamen and traders. Others were distinctly Indian in concept. This small stone pipe utilizes the form of a frog, with the pipe bowl in his back and a hole for the stem under his chin. The concept is not unlike that seen in the design of animal-shaped grease dishes from precontact times.

88. **Pipe.** Wood, iron, abalone shell.
L. 3½ in. 25.0/306

Another interesting adaptation of introduced materials is often seen in smoking pipes in which sections of musket barrels and pieces of gunstock wood have been combined to form the body and bowl. This pipe is an example of that usage. The bowl, judging by its thickness and diameter, has been cut from a standard trade musket barrel. The head of a bird, perhaps an eagle, is carved around the base of the bowl with stylized feet trailing behind toward the stem. Abalone shell has been inlaid in the eyes, the mouth, and around the back of the head.

86. Tlingit Carved Figure

89. Pipe. Wood, copper. H. 5 in. 25.0/239

This pipe is one of the finest of its type. It is probably a Tlingit piece from the early years of the nineteenth century. A human figure with the claws of a bear grasps the pipe bowl, large and barrel-shaped, between his knees and with his clawed hands. The somewhat flattened limbs and the planes of the face show formline influence. The round face with broad, ribbonlike lips and convoluted ear detail is characteristic of early Tlingit work. The pipe bowl has been lined and rimmed with sheet copper to protect the wood from the heat of the burning tobacco.

The pose of this figure is remarkably like that seen in the archaic "seated human figure bowls" of the Georgia Straits Salish area, some of which have surprising similarity to northern carving. Whether this resemblance is more than coincidental would be difficult to show (Duff 1956).

A combination of excellent design, fine workmanship, and rich patination have resulted in a pipe of masterpiece quality.

90. Crooked Knife. Wood, steel.
L. 13⅜ in. 25.0/291

Shell and beaver tooth knives were probably the aboriginal prototypes of the crooked knife of historic times. Knives with long handles and upward-curved blades meant to be drawn toward the carver were used over a good part of northern North America. The version of this "man's knife" common to the Northwest Coast typically has a rather short, double-edged blade with a gradually increasing curve mounted on the underside of a slim handle. The knife is held with the palm of the hand up and the thumb extended along the handle and generally drawn toward the carver, although the double edge allows convenient switching to a pushing stroke.

The handle of this knife is made from an open-grain hardwood, dark brown in color, which has been decorated by carving in low relief. The meaning of the design is not apparent. As in many knives of this type, a shallow depression is carved on the edge of the handle to fit the carver's thumb.

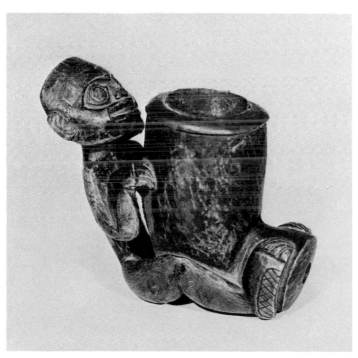

89. Pipe

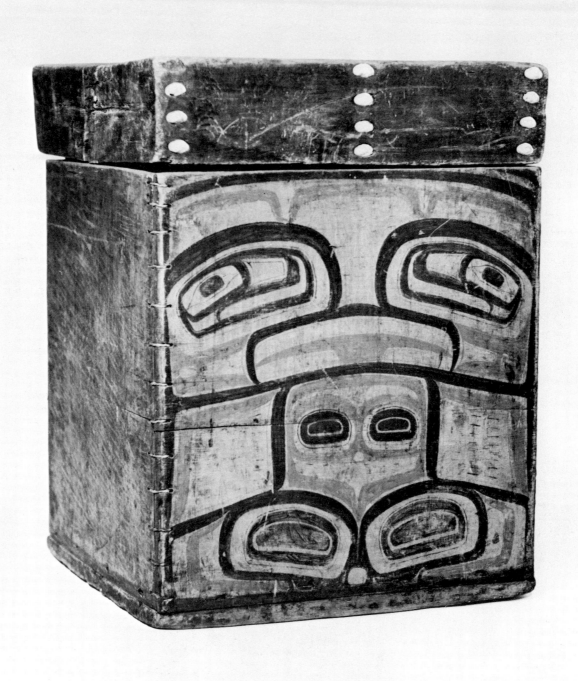

91. Storage Box

91. Storage Box. Wood.
 H. 24 in. with lid. 25.0/246

One of the unique technical achievements of
Northwest Coast Indian artisans was the bent box.
Containers of many sizes and uses were made by
kerfing handmade boards at carefully measured
intervals and bending the boards at the steamed
kerfs to form the continuous sides. The last corner
joint and the bottom board were fastened by
pegging or sewing. On certain types of boxes and
chests, massive lids were fitted, carved of blocks
of red cedar and sometimes decorated on the
edges with inlays of the red turban shell opercula.
This box is of that type. The plan of the box is
nearly square, and two opposite sides are
elaborately painted in red and black in the
conventional style of box painting. Although it falls
within the range of conventional designs on square
boxes, the painting on this box is unusual for its
very early stylistic characteristics. The somewhat
angular and massive formlines of relatively uniform
width and the occurrence of certain details such as
the complete ovoid relief line in inner ovoids
suggest early nineteenth-century northern work.
While literally hundreds of these square boxes exist,
there are apparently no two the same, and even
boxes with both painted sides alike are extremely
rare.

92. Small Box. Wood. H. 5½ in. 25.0/244

Although of the same basic construction, this small
box differs from the preceding one in several
ways. In addition to being very much smaller, it
is decorated on all four sides, and this decoration
is carved rather than painted. Some boxes and bent
corner dishes were both painted and carved, and in
the case of dishes the paint often wore off as a
result of suffusion of oil in the wood. No trace of
paint appears on this piece, however. The formline
designs are constructed exactly the way they would
be in paint, illustrating the strength of the painting
tradition from which the formline design system
was developed.

Perhaps this small container, although rather tall
and narrow, should be called a dish, since it has
the undulating rim and slightly bulging sides
characteristic of northern bent dishes. The
organization of the elaborate distributive design is
also dishlike, in depicting the represented animal,
highly abstracted, wrapped entirely around the
object. The head occupies one of the tall sides in a
complicated bilaterally symmetrical composition.
The two sides of the creature are shown on their
respective sides of the container as asymmetrical
designs, and the animal's hindquarters fill the
remaining tall side, again in a symmetrical
arrangement.

The workmanship in both the structure and
decoration of this small box is of the highest
quality. The Indian artist's concern with the
esthetic aspect of functional objects is very
apparent in this piece.

92. Small Box

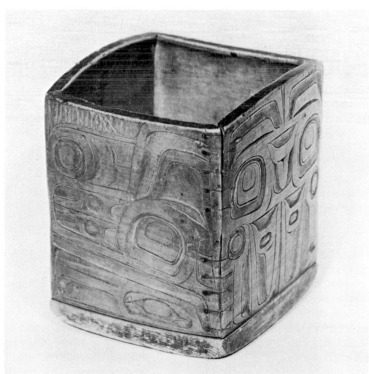

79

99. Spoon. Haida. Horn. L. 10½ in. 25.0/296
The finest horn spoon in the Gerber Collection is
this old Haida piece. Stylistically, the carving
places it toward the first half of the last century.
The four figures, which seem to be a sea bear with
a man astride his dorsal fin, plus two more bears,
are beautifully designed and interrelated in the
classic Haida style. Early spoons of this type seem
not to have been polished since they retain the
marks of the carving tool and the very crisp
corners and planes that result from finishing with
the tool. The handle and the bowl are black
streaked with gray and brown, the natural color
of the horn. The bowl has been fitted into the
hollow at the base of the carved handle and
fastened in place with two rivets.

100. Spoon. Tlingit. Horn, abalone shell.
L. 10⅜ in. 25.0/295
This spoon is made of two pieces of horn of light
brown color. The bowl is very thin and translucent.
The carved figures appear to represent a
Thunderbird, a bear, and a man in a style and
configuration suggesting Tlingit origin. Abalone
shell has been set into the eyes of two of the
figures, and the thunderbird's sharply recurved
beak is fashioned of a separate piece of horn.

101. Spoon. Tlingit. Horn, abalone shell, silver.
L. 13 in. 25.0/294
Spoons of single pieces of horn, either mountain
sheep or, in recent times, domestic cow, were made
by the Tlingit. This broad-bowled ladle appears to
be of sheep horn. The bowl and shank of the
handle have been worked very thin and shaped by
steaming and bending. The finial of the handle is
left with its natural curve and carved to represent a
bearlike creature and a bird. Both have eyes of
abalone shell. A crack in the handle has been
repaired with two plaques of silver, with the one on
the upper face of the spoon roughly engraved. The
spoon appears to be fairly old and made for
native use. Spoons resembling this one were made
in fairly large numbers by Tlingit craftsmen for sale
to tourists. They are generally made of cow horn
and differ from this spoon in the character of the
carving on the handle.

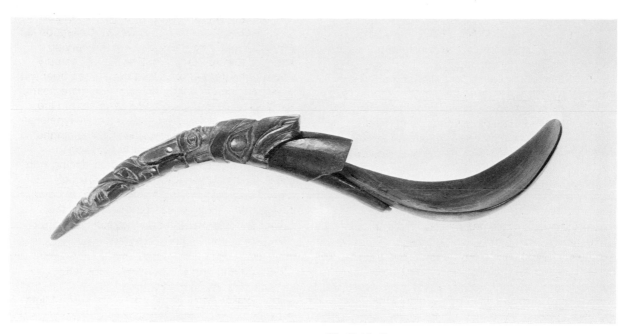

98. Haida Spoon

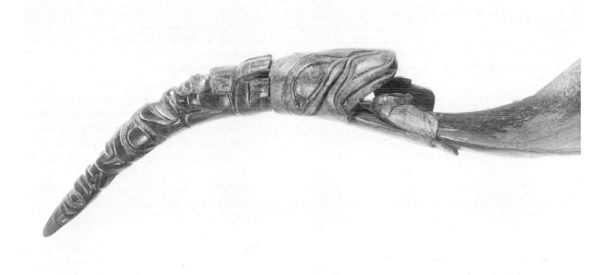

99. Haida Spoon

102. Halibut Hook. Wood, iron. L. 9⅝ in. 25.0/323

The lives of Northwest Coast Indians were, and are today, largely dependent on the bounty of the sea. Over the centuries of occupation of the coast, means of harvesting the many foods produced in the local waters were developed, many of them extremely efficient. Many modern commercial fishing techniques are based on ancient Indian models. One of the most important of the sea creatures furnishing food to the Indians was the halibut. It was abundant in certain waters, could be caught with native-made equipment, and had a tasty and nutritious white flesh that could be dried and preserved. Surplus dried halibut beyond the winter needs of the people was important trade material in intertribal commerce.

Techniques of fishing for the huge flatfish were highly developed. Shallow banks frequented by halibut were often far from shore; yet these areas were located and identified by aligning land features in two directions. Halibut grounds so located were frequently considered family or clan property. The gear was ingenious. Single large hooks, or pairs of hooks hung from the ends of a stick, were lowered to the sea bottom on lines made of kelp stem weighted with a boulder. The hooks, being largely of wood and buoyant, floated up to a fixed and carefully calculated distance from the bottom. The hooks are of unique design. Many, like this one, are of two pieces of wood. The lower carved arm is of hard, tough material such as yew. The upper barbed arm is of softer wood. The barb was securely lashed to the end of the upper arm with split spruce root or, in later times, with seine twine so that its point projected into the space between the two arms. The line was passed through a hole in the lower arm and knotted.

The carving on halibut hooks is extremely interesting. The figures represented are often strange combinations of creatures such as this halibut with the head of an owllike being. They are spirit figures and in use are displayed downward toward the bottom where the halibut lie. The fish takes the baited hook and receives the barb in the lower jaw. Most old hooks are well chewed around the shaft of the barbed arm.

Carving on halibut hooks is often simple and rough. Very likely the fisherman himself does the carving, and only if he happens incidentally to be an artist is it expertly designed and finished. The figures are meant to be seen only by the halibut, and their magical power is more important than any artistic excellence.

103. Halibut Hook. Wood. L. 10⅝ in. 25.0/322

This hook is lacking the lashings at the joint of the two arms and the seat of the barb. The short length of cord knotted to the carved arm is of twisted spruce root. The figures carved in the dark brown wood are a bird, perhaps an eagle, clutching the nose of a halibut with its talons.

104. Halibut Hook. Wood, iron. L. 9½ in. 25.0/324

A natural fork of wood has been used in this hook to achieve the V form basic to the instrument. A fork with a sound, strong juncture is necessary in order to withstand the tremendous stresses placed on it by the weight and power of the fish. Indian fishermen claim, however, that halibut submit to these hooks and allow themselves to be hauled in with little resistance. Whether this is owing to the mechanical leverage applied to the fish's jaw by the design of the hook or to the power of the spirit figure carved on it, the hooks are successful. Tlingit fishermen who have made and used them say that the spread of the arms should be measured by the closed fist of the fisherman so that the fish caught by a specific hook will not be too large for the hook owner to bring into the canoe!

The carving on this one-piece hook is of a long-necked sea bird. The barb lashing is of split spruce root.

105. Woven Hat. Spruce root. D. 15 in. 25.0/248

Basketry was highly developed throughout the Northwest Coast, and a number of very distinct subareas can be delineated according to materials and techniques used and the type and form of objects made. The northern coast tribes, especially the Tlingit and Haida, are known for extremely tight, regular, and well-formed basketry of twined split spruce root. Expertly made baskets from that area are among the world's finest. One of the Northwest Coast basketmaker's most interesting products is the hat. Generally conical in shape, with variations in form and structure from one region to another along the coast, they were light, waterproof, and decorative. Among the Nootka and the northern tribes, Tlingit, Haida, and Tsimshian, certain basketry hats were the prized possessions of chiefs and some had the status of treasured crests.

The Gerber Collection has a single hat, probably Tlingit, woven of spruce root in the northern style. It is expertly made, with a cylindrical crown merging smoothly into the flaring brim, and with the traditional arrangement of three-strand twined top and two-strand-with-skip-stitch brim. Many of these hats were painted with totemic designs. The painting on this hat, in black, red, blue, and white, is of lesser quality than the weaving and may be relatively recent work. The figures represented are two killer whales and a raven. This is a type of hat that could be used for everyday wear as well as for formal occasions. True crest hats were displayed only at the most important gatherings, and the display of the hat was often accompanied by the distribution of potlatch payments to validate its high status.

106. Clam Basket. Split root. H. 12½ in. 25.0/327
The form and structure of baskets varied widely by area and also according to the use to which they were put. In the pretourist era, every basket form was functional. The clam basket represents a highly successful solution to an everyday problem in Northwest Coast life. Baskets made to hold clams as they are dug must be rigid and strong, but must allow water and mud to pass through the walls when the clams are rinsed. The solution was a large flaring basket of split spruce or cedar root in the open wrapped twining technique. The basket, full of clams, can be plunged up and down in the water, and the sand and mud clinging to the shells are quickly removed, draining through the sievelike sides.

107. Coiled Basket. Cedar slat and root, bark, grass. W. 19½ in. 25.0/219
An entirely different technique of basketry is represented by the remaining basket in the collection. Coiling is a method perfected by the basketmakers of the Salish of southern British Columbia and western Washington. Their coiled baskets are strong and rigid and were made in many sizes and styles to suit many purposes. Baskets for cooking, gathering, and storing food; baskets for cradles; and baskets for sale to tourists are among the types known. This large basket with lid was probably of the last type. It was beautifully made by sewing successive coils of thin cedar slats together with close, hard stitches of split cedar root. The decoration, in the form of zigzag patterns, is applied with a technique called imbrication, in which strips of cherry bark in dark red and black and grass stems in white are tucked under the root stitches as they are made. The gathering and preparation of the materials and the actual

construction of such a basket require enormous time and effort, and it is remarkable that baskets of fine quality are still being made today. This one was probably made in the early years of this century in the Thompson River area of southern British Columbia.

108. Gambling Bones. Bone, wood, thread. L. 3½ in. 25.0/289 a,b
The gamblers represented by masked performers in the Kwakiutl Tlásulá (No. 35) are dramatizing a game that was played over a wide stretch of western North America and is still very popular in certain areas. Popularly known in the Northwest as "lehál" or "slahál," its Chinook Jargon name, it is a guessing game played with two pairs of bone cylinders and a number of sharpened counting sticks. One of each pair of bones is marked with a groove or stripe around its center, while the other is plain. The game is played by teams. The bones are held by members of one team, while a member of the opposite side guesses the location of the unmarked bones. Spirited gambling songs to the accompaniment of the rapid beating of sticks on a plank are an indispensable part of the game. The bets of individual players are covered by their opposites, and the winning team takes all. Games with particularly high stakes are sometimes very long, requiring one side to acquire all the counting sticks twice in order to win.

These *slahál* bones are typical of the Salish area. They are hollow sections of bone tapered evenly at both ends and decorated with rows of circle-dot designs. The marked bone has additional rows flanking the central groove, which has been wound with black thread. The hollow centers have been plugged with wood. Bones with a reputation of winning are highly prized.

102. Halibut Hook

Haida Argillite Carvings

Among the many fine examples of Northwest Coast Indian art in the Gerber Collection is a remarkable group of Haida carvings in argillite. Unlike the many pieces which the Gerbers purchased in the Kwakiutl country from the native owners, all the argillite was acquired from dealers and collectors in various parts of the world. Most of these carvings are very old, and a few date from the first decade of the art, which is generally believed to have started about 1820 or a few years before. The Burke Museum is very fortunate to be able to add the Gerber argillite to its collection, especially since it includes examples of most of the major types and periods formerly lacking in the museum's collection.

The argillite from which these pieces were carved is a very fine-grained, black, carbonaceous shale which is found in a single quarry on the Queen Charlotte Islands in the vicinity of Skidegate. If there are other sources of the material of the same quality, they are not known. The Queen Charlotte argillite is soft enough to cut with ordinary woodworking tools, and carving with sharp knives or gravers leaves a beautiful black or gray luster which needs no further polishing. In the later years of the art, it has been the custom to sand and polish argillite carvings, but most early work clearly shows the marks of the tools. There is a widespread story that the material when first quarried is very soft (some versions imply that it can almost be modeled like clay) and that it hardens on exposure to the air until it resists all efforts to carve it. These stories are probably based on the fact that argillite, or slate as it is popularly known, is wet when quarried and tends to split into slabs if it is allowed to dry too rapidly. For this reason the carvers protect their stock of material by burying it or sealing the end grain with shellac. It may become slightly more brittle upon drying, but the difference in hardness between fresh argillite and long-dried—even century-long-dried—argillite is practically undetectable.

Of the hundreds of argillite carvings in collections around the world, only a handful are thought to have been made for the personal use of the Haida. These all have the form of amulets. The carving of argillite by the Haida was and is a commercial art aimed at a foreign market. The earliest collection dates are around 1820, and there is no mention of the material or the art in any journal or account before that date. After 1820, travelers frequently mentioned it and even more frequently purchased it, and they have continued to do so until the present day.

The history of this interesting development of Haida art has been the subject of many articles and a few books, the best known of which are those by Marius Barbeau (Barbeau 1953, 1957). The most recent scholarly study of argillite, and one that I believe will have a bearing on our understanding of Northwest Coast Indian art beyond its immediate subject, is Carole Kaufmann's "Changes in Haida Indian Argillite Carvings, 1820 to 1910" (1969). Dr.

Kaufmann chose argillite carvings as the subject of her analysis because they and their general place of origin are immediately identifiable, and since they were made for sale the collection dates probably come very close to the dates of manufacture. Argillite carvers did not confine themselves to working in argillite, but were the same men with the same styles and ideas who were making the masks and chests and crest hats and totem poles used by Haida nobility. Argillite carving may therefore turn out to be a very handy yardstick to Haida art. Dr. Kaufmann included pieces made up to 1910 in her study. Haidas continued to carve the smooth black slate, but until recently very little was produced to compare with the quality of earlier work. In the 1950s interest in native art began to increase among talented Haida craftsmen, and today there are a number producing work in argillite and other materials, growing directly out of the tradition and equaling the quality of the work of their ancestors of a century ago.

109. Pipe. Argillite, metal. L. 3½ in. 25.0/284
One of the finest pieces of argillite in the collection, and perhaps the earliest, is this elegant pipe bowl in the shape of an eagle or thunderbird grasping a killer whale with his talons and beak. The handling of the formline design of the bird's wings and the whale's flippers closely resembles work on very early dishes and rattles from the Haida area. The whole composition of the bird-whale conflict is expressively handled, and the modeling and carved details are of the finest quality. It is totally Haida in concept, even to the use of the whale's blowhole as a socket for the pipe stem. Generally argillite pipes are thought not to have been intended for use, but this one so closely resembles wooden smoking pipes from the northern tribes that it may be an exception. The metal cap of foreign make that closes the pipe bowl in the bird's head adds to the impression that this may have been a functional pipe.

The carving was probably done in the 1820s or early 1830s.

110. Pipe. Argillite. L. 7½ in. 25.0/280
Another very early pipe, this one combining a raven and two human figures in a very compact arrangement, is less skillfully carved. The raven, a favorite subject of argillite carvers in the early period, dominates the composition. The pipe bowl pierces a rectangular block, the sides of which are formed by the large ovoid shoulder joints of the raven. A small human figure is compressed into the space behind the bird's tail and wing feathers, while a much larger man lies beneath the raven's beak, grasping the lower mandible with stubby fingers. His knees are drawn up in typical Northwest Coast style, and his feet rest on the raven's shoulders. The hole for the pipe stem, broken out at one side, emerges from the man's head.

109. Haida Argillite Pipe

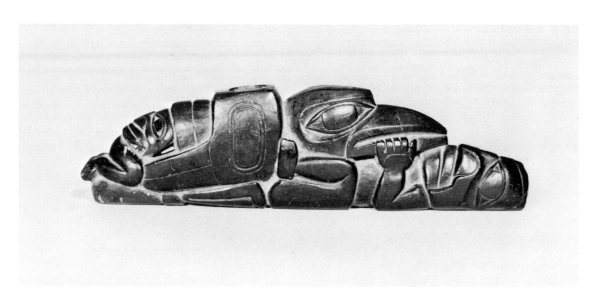

110. Haida Argillite Pipe

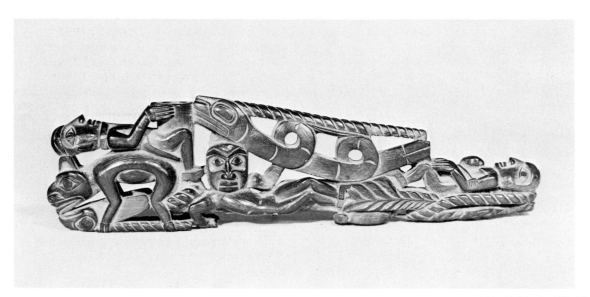

112. Haida Argillite Pipe

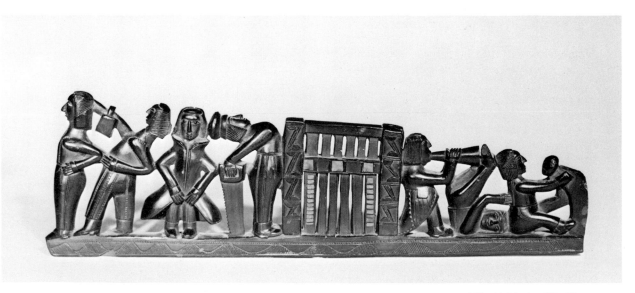

113. Haida Argillite Pipe

111. Pipe. Argillite. L. 7½ in. 25.0/285

This pipe, apparently from the 1830s, is unfinished. The six figures represented are very difficult to identify, partly because of their incomplete state and also because during the period when the piece was carved Haida artists frequently used creatures that combined attributes of different animals as subjects for their work. Also of interest is the fact that some details, particularly in the whalelike figure protruding from the bowl end of the pipe, are executed in a much later style. Perhaps the very early, unfinished piece came into the hands of an artist of the 1890 period who decided to continue the carving.

In addition to the whale, from whose open mouth the head and arms of a man protrude, there is a raven-man who grasps in his narrow beak the tongue of a small human figure. The joined-tongue motif is common in early argillite and is related to the theme carried on in raven rattles (No. 21). The man's flat mouth on a plane perpendicular to his face is very peculiar and somewhat awkward. His arms are merely roughed-out blocks. The legs of the next creature, a bear or wolf, merge with the unfinished arms. A small frog stands between the ears of the bear, his forelegs passing through the formline U delineating the ears and grasping the bear's cheek.

Unfinished works are of particular interest because of the insight they furnish into the artist's methods. This one is especially intriguing with its evidence of a later continuation of the original carving.

112. Pipe. Argillite. L. 11½ in. 25.0/282

Early in the argillite carving tradition, Haida artists began experimenting with exotic subject matter. At the time this excellent pipe was carved, it was becoming popular to combine native Haida themes with figures and motifs that were part of the strange new world being opened to the Haida by traders and seamen. The foreigners themselves became the subjects of sculpture, and their accouterments and equipment, even their ships, found places in the new Indian art. This pipe combines almost every design inspiration available to a Haida artist of the period. A traditional Haida wolf crouches over a Haida-style bird, but reclining on the wolf's back and grasping the pipe bowl with his knees and hands is a uniformed Caucasian seaman with heavy shoes, high-collared cutaway jacket, and pointed nose. Stretched along the bottom of the pipe is another human figure, this one a Haida, judging by the conventionalized features and lack of clothes. His feet rest against flowing leaves, a theme borrowed from European sources that was becoming increasingly common in argillite carving. The Indian's body and head are twisted in a naturalistic pose, very different from traditional Haida conventions of art. A double-coiled serpent writhes along the pipe, borrowed almost directly from the scaly cast-brass side plate of the trade musket which had by this time become the Haidas' principal weapon (Holm 1969). At the mouthpiece of the pipe lies a mother suckling her child, and ship's tackle in the form of blocks and ropes, parts of which are missing, frames the whole composition. All of these themes are found on other pipes and argillite carvings of the period. A reasonable estimate of a date for this pipe would be 1830.

113. Pipe. Argillite. L. 14 in. 25.0/276

In the 1840s non-Haida subject matter almost completely dominated the argillite carvers' repertoire. Long "panel pipes," thin slabs of argillite intricately carved and pierced into silhouette friezes of imaginative shipboard scenes, were in style. They are pipes only in that they have a tiny hole drilled down from the top to meet a similar hole drilled along the bottom from one end. Very often, as in this panel pipe, a rectangular motif suggesting a ship's cabin occupies the center. Some are clearly architectural, with windows, moldings, and occupants. Others are abstract impressions of structures. The figures on these pipes are nearly always Europeans, with an occasional animal worked in. Usually they are active, busy at real or imagined sailors' tasks. Their exotic clothing and hairstyles were clearly of great interest to the Haida carvers. Locks of hair and seams in jackets and trousers are carefully rendered. In this pipe one sailor holds his shipmate's hair from the back. A frock-coated officer stands with arms akimbo between him and a seaman with cap and handsaw who is bending backward from the waist. Aft of the cabin another officer shouts orders through his megaphone past the upraised feet of an inverted acrobatic sailor, whose neighbor holds a curved post with head-shaped finial.

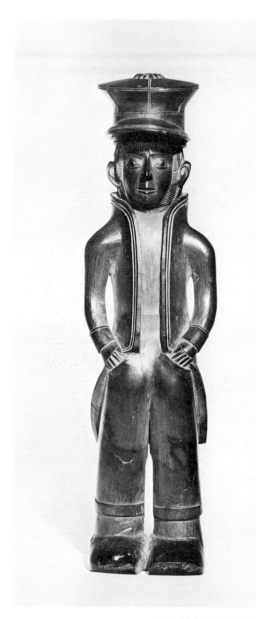

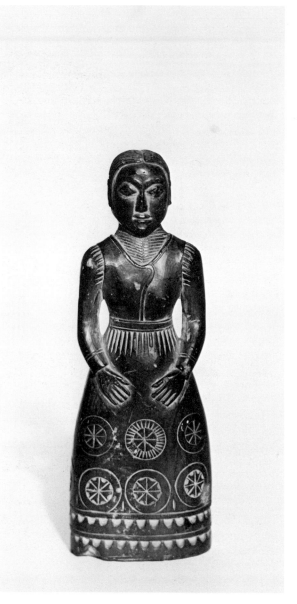

114. Haida Argillite Figure

115. Haida Argillite Figure

114. **Figure.** Argillite. H. 13¼ in. 25.0/286
Another popular subject for the argillite sculptor of
the 1840s was the individual figure of the "sea
captain." These are essentially portraits, but they
have the qualities of caricature. This jaunty seaman
is an excellent example. The solid, feet-apart
stance with hands in pockets is practically standard
for all such figures. Massive boots (which intrigued
argillite carvers for decades), trousers, and a frock
coat with its stiff collar and cuffs are rendered
in detail. The face is beautifully modeled, with long
European nose, protruding ears, wavy hair, and
sideburns. Crowning all is a magnificent peaked
cap with seams, welts, and pompon meticulously
carved.

115. **Figure.** Argillite. H. 6 in. 25.0/279
Figures of women in the fashion of the day appear
around the middle of the nineteenth century in
panel pipe groups and as single figures. They are
usually thought to represent white women, but some
may depict Haida women in the European dress
which they were beginning to assume at the time.
Here again the artist has given considerable
attention to the depiction of hair and clothing
details. Seams and gathers are realistically shown,
but the decoration of the skirt is composed of
stylized motifs in use by argillite carvers of the time.

116. Haida Argillite Plate

116. Plate. Argillite. D. 12 in. 25.0/281

This round plate is probably from the same period as the delicate lady above. Many were made in the mid-century, very often with this kind of geometric and floral decoration. Some of the inspiration for these plates probably came from English tableware of the time, and certain of the motifs may derive from scrimshaw designs developed by American whalers, especially the wheellike rosette, which has been likened to the jagging wheels made by the scrimshanders (Kaufmann 1969:130).

The dish is perfectly round, with a compass center attesting to the intent of the artist. The leaves and berries spiraling around the rosettes and the hatching in intervening spaces are all characteristic of Haida plates of the period. The inside of the plate is unfinished. Compass-drawn lines indicate the plan, which was never carried out.

The plates, like almost all argillite carvings, were purely decorative and were not intended for use.

117. Panel Pipe. Argillite. L. 9½ in. 25.0/278
A beautifully finished panel pipe characteristic of
the work of the mid-century resembles the
ship-motif pipes of the 1840s. The central element
has lost its architectural character and has become
a highly stylized decorative element pierced by the
bowl of the pipe. Waves run the length of the base,
and a curious curly-haired dog with human arms
and legs sits in the stern. Arching over the bow like
a figurehead is a magnificent Yankee angel with
long, curly hair, whiskers, and delicately feathered
wings. The seams of his clothing and the soles and
heels of his boots are clearly depicted. Flowers,
leaves, and berries fill the remaining spaces.

118. Pipe. Argillite. L. 9½ in. 25.0/283
Argillite pipes are sometimes made in imitation of
the form of clay trade pipes. These have long, thin
stems and small cup-shaped bowls, some of which
are made in the shape of a human head. This style
appealed to argillite carvers, and they added it to
their repertoire. Generally the slate carver added
other figures to the basic pipe form. This pipe from
the 1860s or 1870s shows the type clearly. The
basic form of the trade pipe is followed, with the
addition of a large insect balanced on the stem.
Winged insects with large round eyes, coiled
proboscis, and segmented body have been
generally referred to as dragonflies when they occur
in Indian art. They are seen more often on argillite
pipes of the early decades than anywhere else.

The man's head on the bowl of the pipe is very
unusual for its narrow arched nose, heavy eyebrows
and mustache indicated by hatching, wrinkles on
the cheeks, and closed eyes. Interestingly, all the
inner ovoids on the eyes and joints of the dragonfly
are relieved with curved slits which suggest closed
eyes.

119. Figure Group. Argillite. H. 6 in. 25.0/275
In the last quarter of the nineteenth century, carvers
began to produce compact sculptural groups of
figures of animals and men. Some of them are
extremely complex, with many figures crowded
together in contorted positions. Incidents from
myths were often depicted. Another favorite subject
was the shaman in his regalia. This group,
stylistically from the 1890s, has the bear as its main
figure, like many others of the time. The bear holds
a man in its jaws and a cub on its lap. A man with a
woven hat sits behind the bear, and the figure of
a shaman with a peculiar hairstyle kneels on the
contorted figure of a man. The meaning of the
various figures is not clear, but it is likely that the
group illustrates incidents from the well-known
"Bear Mother" myth.

119. Haida Argillite Figure Group

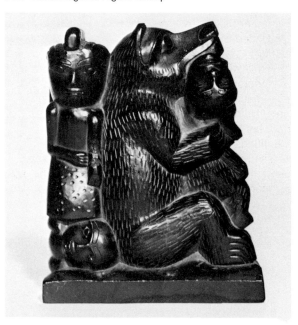

117. Haida Argillite Panel Pipe

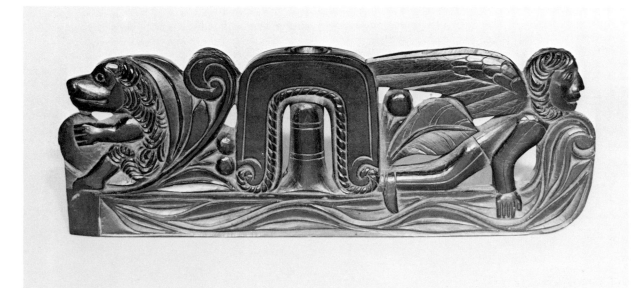

120. Figure Group. Argillite. L. 2¼ in. 25.0/287
This tiny figure representing the sea wolf with his
prey was probably made by Isaac Chapman around
the turn of the century. Chapman and Charles
Edensaw were the principals in a largely mythical
rivalry described in some detail by Marius Barbeau
in his *Haida Carvers* (1957:180–81). Barbeau errs
in many of the attributions given to the argillite
totem poles illustrating the story. Almost all of
Isaac Chapman's works were small in scale. His
carvings were delicate and carefully finished. The
mythical sea wolf holding a whale in his jaws and
another with his tail is a subject frequently seen in
argillite. This one is a good example of work of a
known Haida artist of the turn of the century.

121. Figure Group. Argillite. H. 4½ in. 25.0/277
Unlike the Chapman carving, which is probably
complete as it is, this small carving of a bear biting
a man is a small part of a much larger work. It is the
finial from the lid of an elaborate and beautifully
carved argillite chest, the other parts of which are in
the United States National Museum. This is the
work of Charles Edensaw, the other half of the
"rivalry" with Chapman, and it appears in one of the
few photographs known of that Haida master
(Barbeau 1957:Fig. 170). Edensaw was one of the
great Haida artists, and his work, especially that
from his best years, is among the most easily
identified.

The realistic bear, with its sensitively modeled
head, massive front legs and claws, and dashing to
represent fur, holds the twisted body of a man in
its jaws. Part of the man's head has broken off, and
other cracks appear here and there through the
brittle argillite.

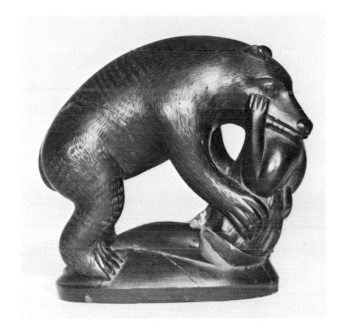

121. Haida Argillite Figure Group

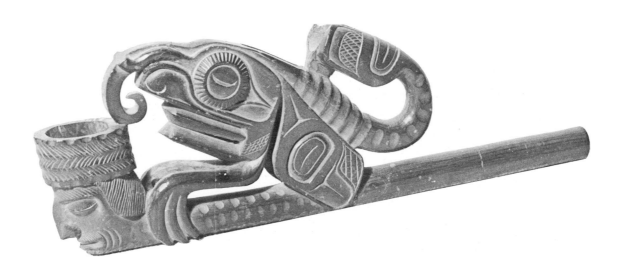

118. Haida Argillite Panel Pipe

Bibliography

Barbeau, Marius
1953 *Haida Myths Illustrated in Argillite Carvings.* National Museum of Canada Bulletin no. 12, Anthropological Series no. 32.
1957 *Haida Carvers.* National Museum of Canada Bulletin no. 139, Anthropological Series no. 38.

Boas, Franz
1897 *Social Organization and Secret Societies of the Kwakiutl Indians.* United States National Museum Report for 1895.
1898 *Mythology of the Bella Coola.* Memoirs of the American Museum of Natural History, vol. 2. New York.
1909 *The Kwakiutl of Vancouver Island.* Memoirs of the American Museum of Natural History, vol. 8. New York.
1921 *Ethnology of the Kwakiutl.* Bureau of American Ethnology, Annual Report no. 35.
1935 *Kwakiutl Tales.* Columbia University Contributions to Anthropology, vol. 26. New York: Columbia University Press.

Culin, Stewart
1907 *Games of the North American Indians.* Bureau of American Ethnology, Annual Report no. 24.

Curtis, Edward S.
1915 *The North American Indian.* Vol. 10, *The Kwakiutl,* reprinted 1970 by Johnson Reprint Co., New York and London.

Duff, Wilson
1956 *Prehistoric Stone Sculpture of the Fraser River and Gulf of Georgia.* Anthropology in British Columbia, vol. 5. Victoria, B.C.: Provincial Museum.

Duff, Wilson, Bill Holm, and Bill Reid
1967 *Arts of the Raven.* Vancouver, B.C.: Vancouver Art Gallery.

Drucker, Philip
1940 *Kwakiutl Dancing Societies.* Anthropological Records, vol. 2, no. 6. Berkeley and Los Angeles: University of California Press.
1971 *The Northern and Central Nootkan Tribes.* Bureau of American Ethnology, Bulletin no. 144.

Drucker, Philip, and Robert Heizer
1967 *To Make My Name Good.* Berkeley and Los Angeles: University of California Press.

Emmons, George T.
n.d. Collection notes in Thomas Burke Memorial Washington State Museum. Seattle, Wash.

Ernst, Alice
1952 *The Wolf Ritual of the Northwest Coast.* Eugene: University of Oregon Press.

Feder, Norman, and Edward Malin
1968 *Indian Art of the Northwest Coast.* Denver Art Museum Quarterly, Winter 1962. Revised edition 1968. Denver, Colo.

Ford, Clellan S.
1941 *Smoke from Their Fires.* New Haven, Conn.: Yale University Press.

Gunther, Erna
1956 "The Social Disorganization of the Haida as Reflected in Their Slate Carvings." *Davidson Journal of Anthropology* 2:149–53.

Hawthorn, Audrey
1967 *Art of the Kwakiutl Indians and Other Northwest Coast Tribes.* Seattle and London: University of Washington Press.

Holm, Bill
1965 *Northwest Coast Indian Art: An Analysis of Form.* Seattle and London: University of Washington Press.
1969 "The Trade Gun as a Factor in Northwest Coast Indian Art." Unpublished paper read before the 22nd Northwest Anthropological Conference, Victoria, B.C.
n.d.1 "Humsumala: The Cannibal Mask Dance of the Southern Kwakiutl." Unpublished manuscript.
n.d.2 "The Art of Willie Seaweed, a Kwakiutl Master." Unpublished manuscript.

Jones, Joan Megan
1968 *Northwest Coast Basketry and Culture Change.* Burke Museum Research Report no. 1. Seattle, Wash.

Kaufmann, Carole
1969 "Changes in Haida Indian Argillite Carvings, 1820 to 1910." University Microfilms Xerox. Ann Arbor, Mich.

Keithahn, Edward L.
1964 "The Origin of the Chief's Copper." *Anthropological Papers of the University of Alaska* 12(2):59–78.

Mochon, Marion Johnson
1966 *Masks of the Northwest Coast.* Milwaukee Public Museum Publications in Primitive Art, no. 2. Milwaukee, Wis.

Niblack, Albert P.
1888 *The Coast Indians of Southern Alaska and Northern British Columbia.* Report of the United States National Museum for 1888, pp. 225–386.

Olson, Ronald L.
1954 *Social Life of the Owikeno Kwakiutl.* Anthropological Records, vol. 14, no. 3. Berkeley and Los Angeles: University of California Press.
1955 *Notes on the Bella Bella Kwakiutl.* Anthropological Records, vol. 14, no. 5. Berkeley and Los Angeles: University of California Press.

Orbit Films
1951a *Dances of the Kwakiutl.* Seattle, Wash.
1951b *Fort Rupert.* Seattle, Wash.

Spradley, James P.
1969 *Guests Never Leave Hungry.* New Haven and London: Yale University Press.

Swan, James G.
1874 "The Haidah Indians of Queen Charlotte's Islands." *Smithsonian Contributions to Knowledge,* vol. 16, no. 4.

Swanton, John R.
1909 *Contributions to the Ethnology of the Haida.* Memoirs of the American Museum of Natural History, vol. 8. New York.

Waterman, T. T.
1923 "Some Conundrums in Northwest Coast Art." *American Anthropologist,* N.S. 25:435–51.